Nicaragua

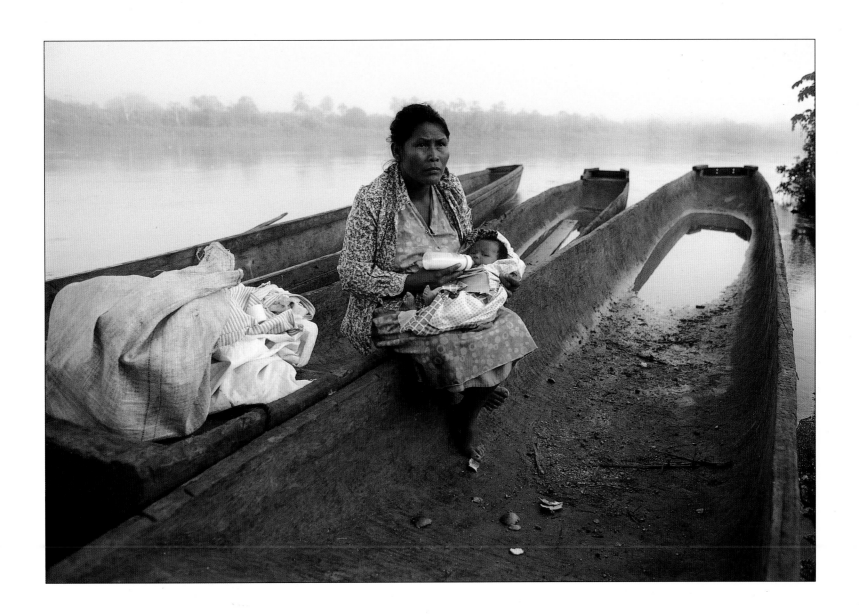

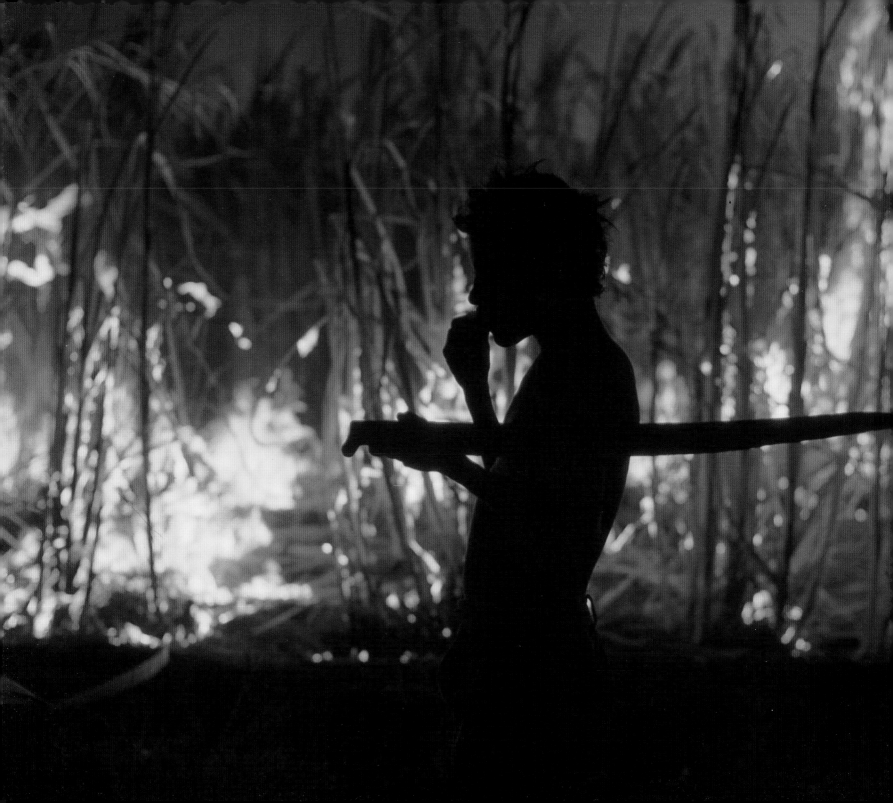

Nicaragua

PHOTOGRAPHS BY WILLIAM FRANK GENTILE

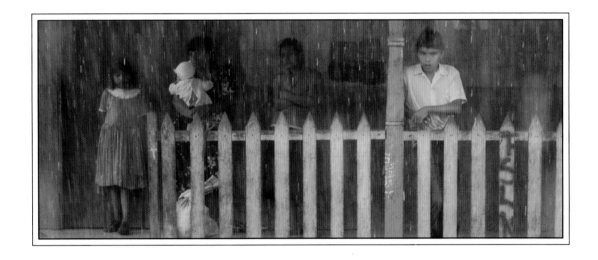

Introduction by William M. LeoGrande

An Interview with Sergio Ramírez Mercado

W · W · NORTON & COMPANY · NEW YORK · LONDON

Printed in Japan

The text of this book is composed in Clarendon Light
Composition by Trufont Typographers
Manufacturing by Dai Nippon Printing Company
Book design by Candace Maté

Translation of Interview by Kathleen Weaver

First Edition

Library of Congress Cataloging-in-Publication Data

Gentile, William Frank.
 Nicaragua / Photographs by William Frank Gentile.—1st Ed.
 p. cm.
 1. Nicaragua—Description and travel—1981– —Views.
 2. Nicaragua—Social conditions—1979– —Pictorial works.
I. Title.
F1524.G47 1989 972.85′053—dc 19 89-2944 CIP

ISBN 0-393-02697-3
ISBN 0-393-30603-8 (pbk)

W.W. Norton & Company, Inc. 500 Fifth Avenue New York, N.Y. 10110

W.W. Norton & Company Ltd. 37 Great Russell Street London WC1B 3NU

1 2 3 4 5 6 7 8 9 0

Contents

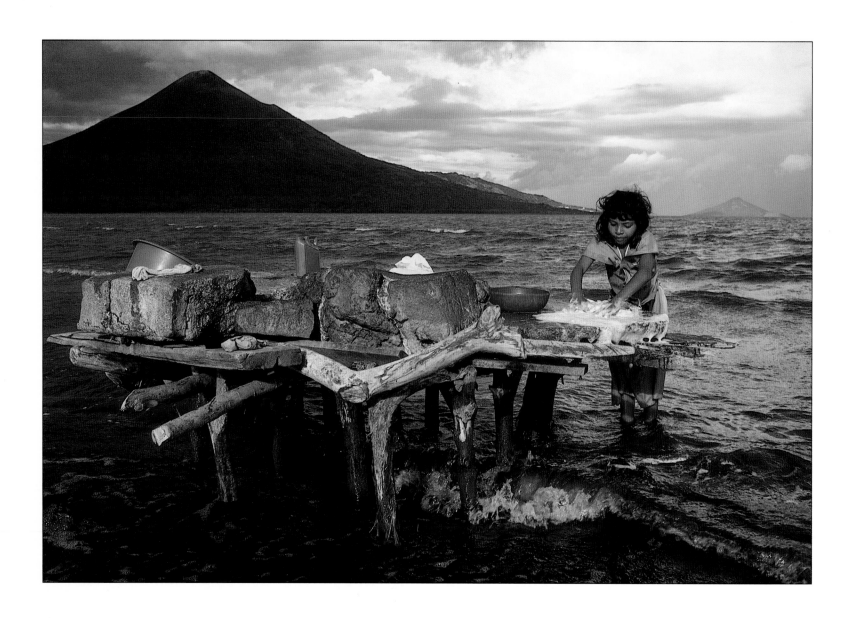

*For my mother, my brothers Lou, Dave and Rob
and my compañera, Claudia*

Acknowledgments

This book is a tribute to Nicaragua and her people, who have so enriched my life and who have shown me an alternative way to live it.

I first came to this country in 1979, as a correspondent and then as a photographer, to cover the Sandinista Revolution. That was the first step in the 10-year-long progression to this book.

In the decade between that first step and the present, I was extremely fortunate to have made contact with the people who, either directly or indirectly, have contributed to the completion of the project. And for me, part of the beauty of this endeavor lies in the friendships I've forged along the way.

First and foremost, I thank the people of Nicaragua whose generosity and courage allowed me into their homes and into their hearts.

Special recognition for a special family: Dr. Alberto Baca Navas, whose strong convictions led me to reconsider some of my own; his wife, Norma, a magic woman who taught me to love the smell of the land after a rainfall; their children, who took me in as one of their own.

Newsweek magazine, for whom I've worked as a contract photographer in Latin America and the Caribbean since 1985 (and freelance photographer since 1983), has never wavered in its support. The staff of the Photography Department have been not just colleagues but friends.

Jim Colton, my former editor at Newsweek, has been with me on this project since 1986, longer than anyone else at the magazine. He has sifted through hundreds of thousands of slides to help select the 96 that appear in this volume. His encouragement and advice on editorial and technical matters have been crucial. Hilary Raskin worked mostly as my agent with the publisher, but also as an excellent counselor on conceptual issues; she persuaded me to vary and improve the format of the book. Karen Mullarkey, Newsweek's Chief Picture Editor,

had the vision to give me the time I needed to go out and complete this work. And then she had the conviction to pull me back in and tell me it was time to move on to something else. John Whelan was my first supporter at the magazine.

No photographer could ask for more.

Leonardo Lacayo Ocampo generously shared the knowledge and wisdom acquired over decades of hard work, to help me construct the foundations of this book.

Omar Cabezas, in the initial stages of the project, introduced me to the spirituality of his country and his people—an introduction vital to the tone of the document.

Josecho Xaldua, a fine journalist and a wonderful friend, took the time to offer his thoughtful perceptions and analyses of Nicaragua, her people and her government.

"El Cuervo" taught me much about survival in the merciless mountains of his country. May he find the peace in death that so eluded him in life.

To cover the Sandinista-Contra war, Arturo Robles and I shared countless missions into the fray, and I cherish them, as I do every hour and mile spent on the road with Scott Wallace and Joe Contreras. My youngest brother, Rob, arrived in Nicaragua in time to help me smooth out some of the bumps and rough edges I had acquired during those previous trips, and I am grateful for that.

The contributions of William LeoGrande and Sergio Ramírez have been essential in making this document complete. My editors at W.W. Norton, Bill Rusin and Ferenc Maté, have given me the criticism, the confidence, and the freedom I've needed to do this book properly.

But more than any other single person there is a special one to whom I owe the greatest thanks and recognition. Throughout my love affair with her country, this marathon against the wind, she never missed a step at my side. She sharpened my senses and steadied my hands. She is my friend, my ally, and my compañera— Claudia.

William Frank Gentile
January 1989
Managua, Nicaragua

Introduction

NICARAGUA AND THE UNITED STATES: A LONG EMBRACE

William M. LeoGrande

The history of U.S. involvement in Nicaragua stretches back to the California Gold Rush in the middle of the nineteenth century. In 1848, as a result of the war with Mexico, the United States acquired the western territories of New Mexico, Arizona, Nevada, Utah, Colorado, and California, thereby fulfilling its Manifest Destiny to control all the territory between the Atlantic and Pacific oceans. To reach the west, however, required months of a perilous journey across the plains and the Rocky Mountains. Commerce between the coasts was nearly impossible. The potential for a passage across the isthmus of Central America began to attract serious interest from the United States. The California Gold Rush of 1848 set off a stampede of people into the newly acquired western territories, and gave new urgency to the idea of a Central American canal.

Like Panama, Nicaragua was always regarded as a logical site for a canal. By travelling up the San Juan river and across Lake Nicaragua, a shallow-draft boat could get within 12 miles of the Pacific coast. In 1853, Cornelius Vanderbilt established a lucrative business transporting travellers across Nicaragua by building a decent road over that 12-mile-wide finger of land. Finding Nicaragua's climate congenial, many of the travellers gave up their plans to go to California and stayed.

With U.S. business came the gunboats of the U.S. government, intent upon preserving the honor and interests of its citizens. The first of 11 U.S. interventions in Nicaragua came in 1853 when a contingent of Marines landed on the Atlantic coast to settle a dispute between Vanderbilt's transit company and local Nicaraguan authorities. They resolved it in Vanderbilt's favor, of course.

In 1854, a U.S. diplomat was grazed by a bottle thrown from an angry crowd during a fracas with the mayor of San Juan del Norte, a small Atlantic coast port. In retaliation, a naval gunship bombarded the town until hardly a building remained standing. A landing party of Marines then looted the ruins and put them to the torch.

All this was merely a prelude, however, to one of the most amazing and, for Nicaraguans, most galling episodes in the history of U.S. relations with Latin America. In 1854, the Nicaraguan Liberal and Conservative parties were engaged in a civil war, and the Liberals appealed to a North American named William Walker to raise a contingent of filibusters—mercenaries—to bolster their forces. Walker's troops managed to capture the Conservative capital of Granada and, by holding the wealthy families of the Conservative leaders hostage, Walker forced them to surrender. Calling himself "the Gray-Eyed Man of Destiny," Walker then took control of the Nicaraguan government, had himself elected president, made English an official language, and legalized slavery.

The occupation of Nicaragua by Walker and his filibusters had at least one salutary effect: It led the states of Central America, which more often than not were engaged in fratricidal conflicts with one another, to set aside their differences and unite to oust this Yankee interloper. In 1856, the combined armies of Central America drove Walker out of Nicaragua. When he tried to return in 1860 to resume the war, he was captured in Honduras and shot.

The first two decades of the twentieth century were traumatic ones for U.S. relations with Latin America. These were the years of Gunboat and Dollar Diplomacy, when the United States sought to make Central America and the Caribbean safe for the United States. Behind this interventionist impulse was the rapid expansion of U.S. interests, both economic and strategic. The closing of the frontier marked the fulfillment of Manifest Destiny, but not its satiation. As U.S. economic power grew, entrepreneurs began to seek profitable investment opportunities beyond the bounds of North America. Naturally they were drawn to the regions lying on the geographic periphery of the continental United States—Mexico, Cuba, Central America, and the Caribbean. As the economic interests of U.S. business extended into these regions, so too did their stake in political stability. When that stability appeared tenuous and investments were in jeopardy, the U.S. government was not loathe to deploy gunboats and Marines to protect them.

The turn of the century also marked the emergence of the United States as a world power. At this same time, the Great Powers of Europe were busy carving up the Third World into colonial domains. Latin America was safe from European depredations by virtue of the 1823 Monroe Doctrine, in which Washington declared its willingness to fight to prevent any European effort to recolonize the New World. But as the United States itself entered the ranks of the Great Powers, the western hemisphere seemed to be its logical domain. To justify the subordination of Latin America to the United States, the doctrine of the "New Manifest Destiny" emerged: It

was Washington's natural right to expand its influence throughout the hemisphere, just as it had been its natural right to span the continent. The Roosevelt Corollary to the Monroe Doctrine, articulated in 1904, declared Washington's right to intervene anywhere in Latin America to be a civilizing mission—a duty to maintain order and stability for the benefit of all.

A strategic imperative also lay not far beneath this veneer of self-justification. With the completion of the canal across Panama, the entire Caribbean Basin took on a strategic importance hitherto unknown. The defense of the canal was vital. To ensure it, Washington sought to prevent European powers from gaining a foothold anywhere in the Basin, lest they establish military bases from which they might attack the canal. Political instability or financial insolvency in neighboring countries became intolerable, because it offered Europeans an opportunity to intervene. For Washington, preventive intervention became the preferred response.

Nicaragua was among the countries most often victimized by the New Manifest Destiny. Although Washington finally chose Panama for the canal route, Nicaragua was nonetheless strategically located. In 1912, it became a virtual protectorate of the United States when 3000 U.S. troops landed, ostensibly to protect American lives and property during a period of civil strife. They stayed for 13 years, during which they guaranteed the survival of the Conservative Party government. Asked in 1922 what prospects the Conservative government of Adolfo Díaz would have if the Marines left Nicaragua, W. Bundy Cole,

a New York banker who was the manager of the National Bank of Nicaragua, answered, "I think the present government would last until the last coach of Marines left Managua station, and I think President Díaz would be on that last coach."

In 1925, the Marines did leave briefly, and Cole's prediction was proven correct. The Liberals took up arms against the Conservatives almost immediately, and in 1927, 6000 Marines returned to restore order, fighting, not coincidentally, on the side of the Conservatives. But the United States never quite succeeded in pacifying Nicaragua during the second occupation. Augusto Cesar Sandino, a military leader of the Liberal Party, refused to accept Washington's imposition of a Conservative president. Leading a ragtag "Army for the Defense of Nicaraguan National Sovereignty," Sandino fought a six-year-long guerrilla war against the U.S. Marines, achieving international stature as a nationalist and an anti-imperialist.

The U.S. war against Sandino left a bitter legacy. "Today we are hated and despised," wrote an American coffee planter in Nicaragua in 1931. "This feeling has been created by employing the American marines to hunt down and kill Nicaraguans in their own country." Despite President Calvin Coolidge's warning that Sandino was an agent of Bolshevik Mexico, which was intent on extending Soviet-style Communism to all of Central America, opposition to the futile war began to rise in Washington as well. In 1932, Congress refused to finance any additional troop deployments for the Nicaraguan war.

When Washington finally withdrew from Nicaragua in 1933 under the auspices of President Franklin D. Roosevelt's Good Neighbor Policy, it left the task of ensuring Nicaraguan stability to a U.S.-trained constabulary, the National Guard, commanded by Anastasio Somoza García, who had been the liaison between the U.S. Marine commander and the Nicaraguan government. One of Somoza's first achievements was to have Sandino assassinated when he came to the capital, Managua, to arrange peace with the government. In 1936, Somoza forced the civilian president from office, arranged his own election, and thus initiated a family dynasty that ruled Nicaragua for forty-two years.

The Somoza dynasty rested upon two pillars of support: the National Guard, transformed by patronage into the Somozas' personal instrument of political repression; and the support of the United States, ensured by the Somozas' anti-communism and their ability to maintain order. Though the dynasty was far from the civilian democracy envisioned by Washington in the 1930s, it was nevertheless stable and friendly. Although the United States at various times pressured the Somozas to be more tolerant of their political opponents and move toward more democratic rule, it was never willing to risk destabilizing such a reliable ally by pushing too hard. Franklin Roosevelt's apocryphal but oft repeated description of Somoza captured the flavor of Washington's attitude over the dynasty's four decades: "Somoza may be a son of a bitch, but he's our son of a bitch." When the United States took on the task of training Latin American military officers after World War II, more soldiers from Nicaragua's National Guard were trained than from any other Latin American army.

The elder Somoza was succeeded by his sons, Luis and then Anastasio Somoza Debayle, a West Point graduate who spoke better English than Spanish. The last Somoza always seemed a bit anachronistic, peppering his conversation with English slang that had disappeared in the 1950s. His enemies called him "the last Marine."

Though their reign did little to alleviate the tremendous poverty of Nicaragua, one of the hemisphere's poorest countries, the Somozas proved adept at personal enrichment. At the end, Anastasio Somoza Debayle controlled an economic empire worth nearly $1 billion, including one-third of the nation's arable land, the meatpacking industry, the construction industry, the fishing industry, the national airlines, the only television station, radio stations, banks, etc. So complete was his economic control that foreign investors avoided Nicaragua for want of any reasonable investment opportunities.

During the first three decades of the post-war period, opposition to the dynasty was weak and divided. The moderates of the traditional opposition political parties were paralyzed by the Somozas' close ties with the United States; time after time, Somoza lured them into unequal "alliances" with the government. The radical opposition, on the other hand, was contained by ferocious repression. Thus the future of the dynasty seemed secure when, on December 23, 1972, the earth began to move,

changing not only the physical geography of Nicaragua, but its political geography as well.

The political aftershocks of the earthquake that destroyed the capital city of Managua in December 1972, fatally weakened the structure of Somoza's rule. Turning adversity to advantage, Somoza and his cronies enriched themselves shamelessly by stealing international aid intended for earthquake victims. With Somoza in charge of reconstruction, the city of Managua was rebuilt on Somoza's land, by Somoza's construction companies, with international aid funneled through Somoza's banks.

The extent of corruption, together with the expansion of Somoza's economic empire into areas of economic activity previously reserved for other members of Nicaragua's private sector, alienated both the middle and the upper classes. Among Nicaragua's lower classes, the economic adversity caused by the earthquakes stimulated more radical opposition manifested in the wave of strikes, demonstrations, and land seizures which swept the country in 1972–73.

The moderate opposition coalesced around the leadership of Pedro Joaquín Chamorro, a reformist member of the Conservative Party and editor of the opposition newspaper, *La Prensa*. The radical opposition was led by the Sandinista National Liberation Front (Frente Sandinista de Liberacíon Nacional, FSLN), named for nationalist hero Augusto Sandino.

Founded in 1961, the FSLN was one of the many guerrilla organizations spawned in Latin America by the example of the Cuban Revolution. It had scant success during its first decade, being routed by the National Guard in its only two serious military ventures. Then, on December 27, 1974, a band of FSLN guerrillas invaded a Managua Christmas party, capturing a dozen of Nicaragua's most prominent business and political leaders. The guerrillas exchanged their hostages for 14 political prisoners, $1 million in ransom, and safe passage to Cuba. The boldness of the Christmas operation brought the Sandinistas national recognition.

Somoza's embarrassment over the Christmas raid led him to embark upon a war of extermination against the FSLN. He declared a state of siege, and unleashed the National Guard to conduct a reign of terror in the northern departments of Matagalpa, Jinotega, Esteli, Zelaya and Nueva Segovia, where the FSLN had been most active.

Such gross violations of human rights appalled Nicaragua's moderates and earned the Somoza government well-deserved international opprobrium. When the Carter administration unveiled its new human rights policy in 1977, Nicaragua became one of its principal targets. Economic and military aid to Somoza were withheld in order to pressure him into improving his human rights practices. Although the material effect of withholding aid was insignificant, the symbolic impact was immense. Historically, moderate opponents of Somoza had been paralyzed by the unflagging U.S. support that the dynasty enjoyed. With the power of the United States behind him, Somoza seemed unassailable. The Carter Administration's criticism of Somoza and the suspension

of aid galvanized the moderates into active opposition by suggesting that Somoza's ultimate base of power—Washington—was no longer secure.

On January 10, 1978, Pedro Joaquín Chamorro was assassinated in Managua, and the nation erupted in a paroxysm of outrage and spontaneous violence. The insurrection against Somoza had begun. For the next six months, Nicaragua was rocked by sporadic violence—strikes, demonstrations, and street fighting—most of it uncoordinated and organized by a widely disparate array of opposition groups. During this crucial period, the political initiative slipped inexorably from the moderates to the FSLN. The Sandinistas spent those months gathering their forces, stockpiling arms, and organizing the urban and rural poor. Paralyzed by their inability to bring Somoza down by themselves, and their fear of the Sandinistas' radicalism, the moderates spent the time waiting for the United States to push Somoza out of power for them.

But Washington was ambivalent about jettisoning such an old and reliable ally. The foremost objective of the Carter Administration was to prevent the radicals of the Sandinista Front from coming to power, but at the same time, Carter was not willing to become an accomplice in Somoza's repression by giving him the military aid he needed to retain power. So Washington equivocated, seeking some compromise that would ease Somoza out gradually while preserving the basic institutions of his regime. The actions of the United States thoroughly confounded and demoralized Nicaragua's moderates, de-stroying their confidence in Washington and eventually driving them, in desperation, into open alliance with the FSLN.

In August 1978, the FSLN seized the National Palace while the Congress was in session, taking 1500 hostages. The Sandinistas' audacity captured the popular imagination and with it the leadership of the anti-Somoza struggle. As the attackers and 59 newly freed political prisoners drove to the airport for a flight to Panama, thousands of Nicaraguans lined the streets to cheer their triumph.

The Palace assault was followed swiftly by a general strike and small-scale attacks on the National Guard in several cities. To almost everyone's surprise, the guerrilla actions sparked mass insurrections in the cities of Matagalpa, Masaya, Leon, Estelí, and Chinandega. To save the cities from the rebels, the National Guard was forced to destroy them from the air. It took nearly two weeks and over 3000 dead before the Guard prevailed. When the Sandinistas withdrew, taking thousands of new recruits with them, the Guard "mopped up" with hundreds of summary executions. After the September insurrection, no political compromise that would retain Somoza in power was possible.

When the FSLN launched its "final offensive" against the Somoza dynasty eight months later in June 1979, any illusions concerning the viability of the Somoza regime quickly melted away. Within weeks, the FSLN controlled the nation's major cities, virtually all the countryside, and half of Managua.

At Washington's initiative, the Organization of American States convened an emergency session to address the Nicaraguan crisis, at which Secretary of State Cyrus Vance called for Somoza's resignation. But Vance then called for the OAS to form a "peace-keeping force" to intervene in Nicaragua to restore order and, not incidentally, prevent the Sandinistas from defeating the National Guard. The reaction to Vance's proposal may well have marked the nadir of U.S. influence in the OAS. Only Somoza favored it.

After the OAS repudiated Washington's proposal, President Carter's National Security Adviser, Zbigniew Brzezinski, proposed a unilateral U.S. intervention, but President Carter refused to consider such a step in the face of unanimous Latin American opposition. In the Carter White House, the instincts of the Roosevelt Corollary and the spirit of the Good Neighbor Policy could be found in uneasy cohabitation.

On July 17, 1979, President Anastasio Somoza Debayle went into exile in Miami. With him went the entire senior command of the National Guard, as well as its morale. The Guard proceeded to disintegrate ignominiously, and within 24 hours had ceased to exist. Thus was realized the very eventuality that U.S. policy since January 1978 had sought to avoid—a complete Sandinista military victory.

In the wake of Somoza's defeat, U.S. policy toward Nicaragua shifted nearly 180 degrees, from an attitude of outright hostility toward the Sandinistas to an attitude of cautious openness. The change was no less stark for having been forced by circumstances, since it carried the implications that even radical social and political change in Nicaragua did not necessarily endanger the vital interests of the United States.

Nevertheless, considerable tension born of mistrust lay below the surface of this peculiar friendship. The long history of U.S. support for Somoza could not be wholly forgiven or forgotten by Nicaragua's new leaders, nor could they shake the fear and suspicion that Washington might yet concoct a counterrevolutionary scheme to rob them of their victory. In Washington, policymakers could not ignore the Marxist origins of many Sandinista leaders, even though Somoza's defeat had been engineered by a politically heterogeneous multi-class coalition. There was always the possibility that the guerrillas, having won power, would shed their moderate garb, dump their middle-class allies, and steer the revolution sharply to the left, down the road of Cuban-style Marxism-Leninism.

Yet the interests of both Nicaragua and the United States lay in maintaining cordial relations. Nicaragua was in desperate need of foreign assistance to help rebuild an economy shattered by the insurrection. The United States had pledged to help in the recovery effort, but the maintenance of friendly relations was obviously a necessary condition for the fulfillment of that promise. Moreover, other international assistance—from Latin America, Western Europe, and the international financial institutions—would tend to follow the lead of the United States. A deterioration of U.S.-Nicaraguan relations

would therefore have economic ramifications far beyond the aid dollars from Washington alone.

For the United States, maintaining cordial relations with Nicaragua was a means of salvaging something from the failure to keep the Sandinistas out of power. Though, from Washington's perspective, the insurrection had been "lost," perhaps Nicaragua itself need not be. Policymakers in the United States set out, quite consciously, to avoid repeating the errors of 1959–1960, when U.S. hostility drove the Cuban revolution into the arms of the Soviet Union. "The Sandinistas are wearing a moderate mask," observed a senior State Department official. "Our job is to nail it on."

Washington's experiment in accommodating to Nicaragua's new reality came to an end after the Carter Administration. Whereas Carter had sought to forge a new relationship with Nicaragua's revolutionary government, the Reagan Administration came to office intent upon overthrowing it. Reagan's top officials were convinced that the Sandinistas were irredeemable communists whose alliance with Cuba and the Soviet Union was a foregone conclusion. Within a few months, the new administration had already launched a covert program to aid Nicaraguan exiles, most of them former members of Somoza's National Guard, who were launching sporadic raids into Nicaragua from base camps in neighboring Honduras.

With tens of millions of dollars in aid from the Central Intelligence Agency, the "contras," as the exile army came to be known (short for counterrevolutionaries),

were able to resume the Nicaraguan war. After first relying on the Argentine military dictatorship to handle the mechanics of the war, the CIA eventually became fully involved—attacking Nicaragua's ports, mining its harbors, and financing its opposition political parties. The Reagan Administration was so determined to "roll back" Nicaragua's revolution and make it the first successful application of the "Reagan Doctrine" that even when the U.S. Congress prohibited any further aid for the contras in 1984, the administration ignored the law and raised money for the contras illegally by selling arms to Iran.

The second Nicaraguan war, though it was fueled by the United States, was also more divisive for Nicaraguans. The insurrection against Somoza had united the entire nation against a rapacious dictatorship. But the revolutionary social transformation initiated by the Sandinistas after the triumph over Somoza was not universally supported. The upper class and the private sector blanched at the new government's radical redistribution of wealth and income. The middle class resented the Sandinista party's tendency to concentrate all political power in its own hands, proclaiming itself the revolutionary vanguard. The indigenous people of the Atlantic Coast, like the Miskito Indians, resisted the Sandinistas' efforts to change their traditional way of life. And the Church hierarchy resisted the Sandinistas' Marxist ideology as a secular threat to its ecclesiastical power. Still, the Sandinistas had a deep reservoir of popular support to draw on, for it was they who had led

the insurrection against Somoza and inherited the mantle of Nicaraguan nationalism. And it was they who promised a better life to the poor.

When Washington determined to destroy the Nicaraguan revolution, the remnants of Somoza's National Guard provided the skeleton command structure for a contra army, and social conflicts sparked by Nicaragua's revolutionary transformation provided enough of a disaffected popular base for counterrevolution. The contras wrapped themselves in the symbols of Christ and Democracy. The Sandinistas called forth the memory of Sandino and invoked the slogan of the Spanish Republic's war against fascism—No Pasaran; They Shall Not Pass.

As President Ronald Reagan's term of office drew to a close, Nicaragua had been at war for almost seven years. A contra army of some 10,000 combatants faced a Sandinista army of some 75,000. The contras had little prospect of winning the war, but so long as they could rely upon their safe haven in Honduras, the Sandinistas had little hope of ever eradicating them. With well over 50% of the national budget devoted to the war, the Nicaraguan economy was prostrate. Hyper-inflation and shortages of basic commodities were seemingly insolvable problems, and for the first time since 1979, hunger began to reappear.

Nicaragua was in desperate need of peace, but despite efforts by the Sandinistas and the contras to negotiate an end to the war, peace seemed unattainable unless the new Bush Administration proved willing to accept a Nicaragua independent of traditional U.S. control.

Perhaps in the days when the Panama Canal was a vital economic and military lifeline for the United States, Washington had some grounds to argue that an unfriendly government in Nicaragua was an intolerable threat to the United States. But by the last quarter of the twentieth century, the challenge to the United States posed by a radical nationalist and socialist movement like the Sandinistas was more psychological than substantial. Nicaragua did not threaten Washington in any military sense, but it threatened Washington's traditional dominance in the Caribbean Basin. For conservative Republicans who sought to restore the hegemony of the United States in the Western Hemisphere, the triumph of the Nicaraguan revolution was a bitter blow. The prospect of destroying it offered a heartening reassurance that the "American Century" was not over just yet, at least not in our own backyard.

To the great misfortune of Nicaraguans, their country became a symbol, and that symbol became a battleground on which North Americans argued over what role the United States should play in the world and in the hemisphere. The symbolic Nicaragua of Washington's policy debates bore little resemblance to the real Nicaragua, but the policy war in Washington nevertheless spawned a real war, dirty and bloody, devastating the lives of ordinary Nicaraguans. The comment of Salvadoran Archibishop Rivera y Damas on the role of the superpowers in his country's civil war applies equally to Nicaragua: "They supply the weapons, and we supply the dead."

It served no real interest of the United States to see Nicaragua reduced to beggary. On the contrary, a healthy and prosperous Nicaragua was an important link in the Central American economy; the economic well-being of U.S. allies in the region was dependent in part on Nicaragua's economic well-being. Nor did it serve Washington's strategic interest to make Nicaragua a battleground of the cold war, leaving the Sandinistas with nowhere to turn for military aid but Cuba and the Soviet Union. The Sandinistas recognized Washington's overwhelming power and were purportedly willing to come to terms with it, so long as the United States was willing to acknowledge Nicaragua's sovereign right to conduct its own affairs free of coercion from Washington.

Therein lay the seeds for an eventual accommodation between Nicaragua and the United States, and a new relationship based on mutual respect for each other's essential interests. As the Bush Administration began, it was unclear whether Washington was yet willing to accept the fact that the rulers in Managua were no longer our SOBs.

In this book of photographs, William Gentile gives us a collective portrait of contemporary Nicaraguans and their country. The portrait may surprise those whose only vision of Nicaragua has been the strange, distorted image reflected in Washington's policy debates. This is the real Nicaragua of everyday life—of people struggling against the ravages of poverty and underdevelopment, and of people living through the horrors of war. It is a family portrait rather than an official one. Politicians, generals, and cardinals are not the protagonists. Their actions take place off-stage, though we see the reverberations of their battles with one another in the lives of the ordinary people featured here. This is a view of Nicaragua from the bottom up.

Gentile's love of Nicaragua is apparent in the way he captures the physical beauty of the country, but he does not romanticize it. Idyllic images of the countryside are always matched with stark images of the harsh life that ordinary Nicaraguans must endure, and even starker images of war and death.

Nicaragua's peasants are startlingly poor, living close to the earth in rough-hewn houses of a room or two, houses topped by roofs of thatch or corrugated tin. Theirs is a hard, simple existence in which coaxing a living from the soil is full-time work for the entire family, young and old alike. On the Atlantic Coast or the Pacific, across barriers of language and culture, the hardships of daily life are not much different.

For the past decade, the uncertainty and tenuousness of daily life in Nicaragua have been exacerbated by a force even less predictable than the weather and the crops—the war. The timeless struggle against poverty and underdevelopment is now punctuated by the immediacy of the war's bloody toll as it ebbs and flows across the countryside, ripping through the placid pastoral scenery at unexpected moments. Yet the inevitability of its arrival makes it an anticipated though unwelcome guest—like the armed men who at any moment may

appear in the doorway of a poor peasant's home.

The soldiers, too, are part of this family portrait. Ideological and geopolitical alignments define the war's broad strategies, but in the field, most of the men doing the fighting are young and poor. For those who have strong convictions about the righteousness of one side or the other in Nicaragua's war, these photographs of soldiers will be unsettling. It is often impossible to tell the two sides apart. Their youth, their easy camaraderie, their solitude, and their dead give them much in common.

Still, the two armies are not indistinguishable. They have different histories and different allegiances. The contras were born from the remnants of Somoza's National Guard, infamous for its avarice and atrocities. Many of its commanders are veteran Guardsmen. In some of their faces, there is a coldness that bespeaks the loss of humanity that comes from killing too much and too easily. For anyone who has seen photographs from the 1978–1979 insurrection against Somoza, the image is immediately recognizable as the visage of the National Guard.

There are no photographs of the United States in this volume, but the United States is everywhere *presente*—from the USA insignia on a contra's cap to the pinup of Marilyn Monroe, from the baseball team playing a game first brought to Nicaragua from the United States, to the North American visitor handing out bats and balls to Nicaraguan children. And of course, the United States is present most directly through the effects of its policy decisions, through the contras and the war Washington has organized them to wage.

Death is an integral part of war—the routine, unceremonious handling of death on the battlefield, the ceremonial and emotional handling of death by family and friends. In one photograph, a young widow nursing an infant looks out at us over the open casket of her dead husband. The anger in her face, the accusation, is palpable—as if, at the moment the shutter clicked, this poor peasant woman understood that the photograph was her one opportunity to confront the people in the far-off United States who had visited war on Nicaragua and catastrophe on her family. Even in a photograph, it is hard to look that woman in the eye.

William M. LeoGrande is Professor of Political Science in the School of Public Affairs at The American University in Washington, DC.

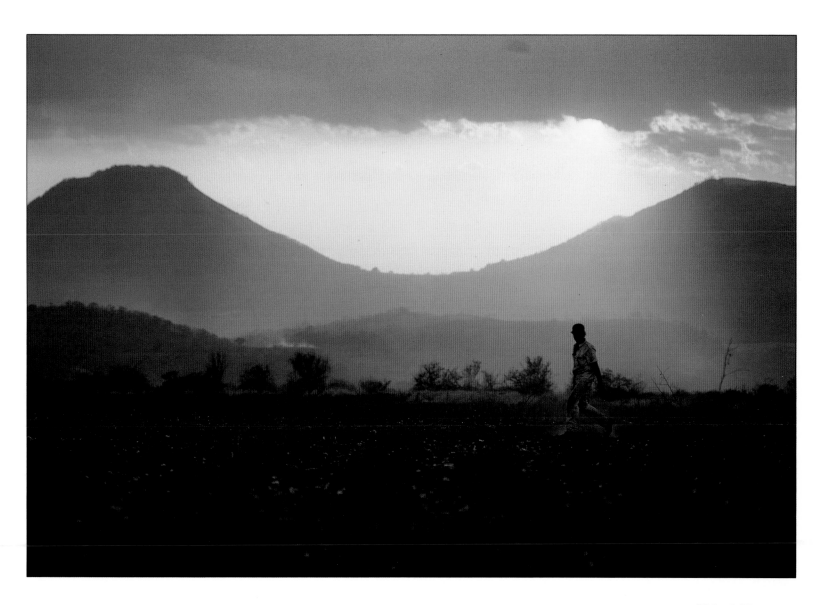

Malpaisillo, 1988.

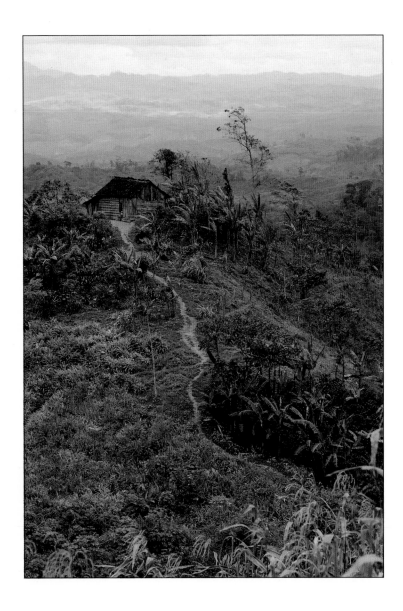

Boaco Department, 1988.

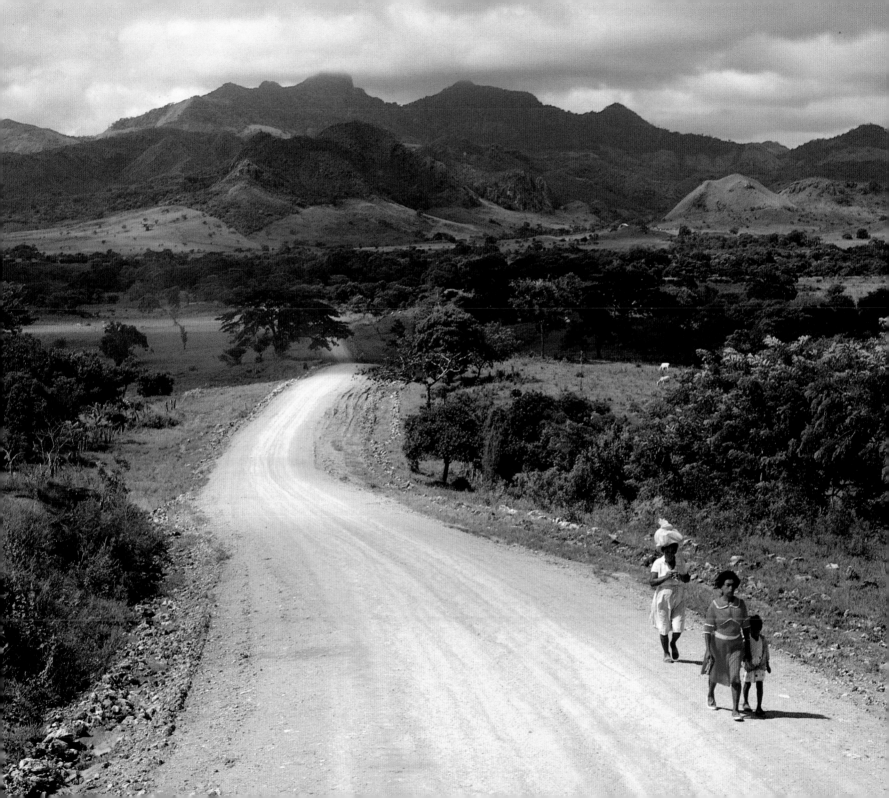

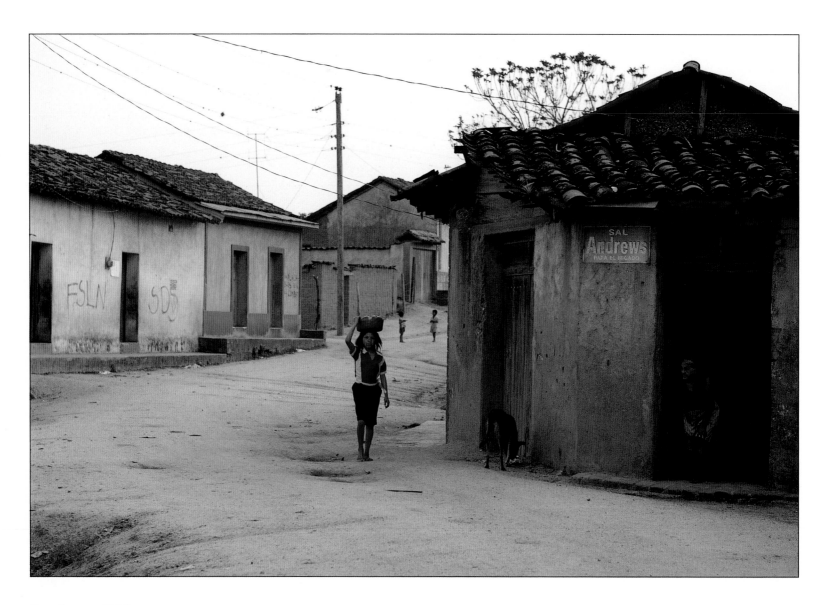

Susukayan, 1988.

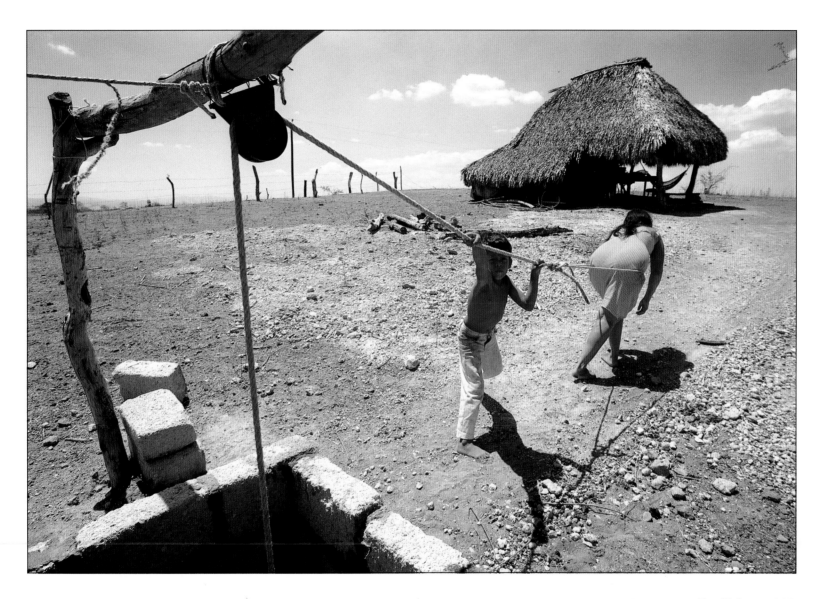

Dry season, Las Brisas, 1988.

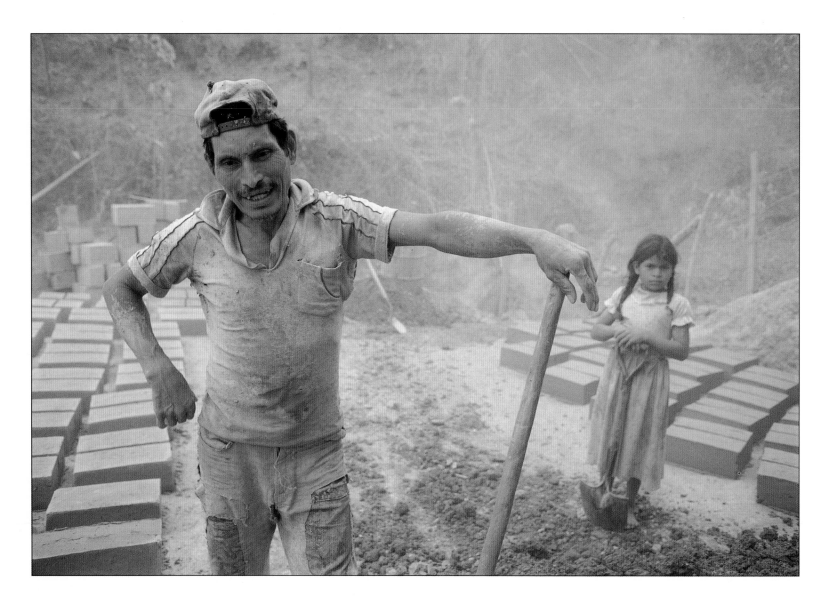

Making adobe, Quilali, 1986.

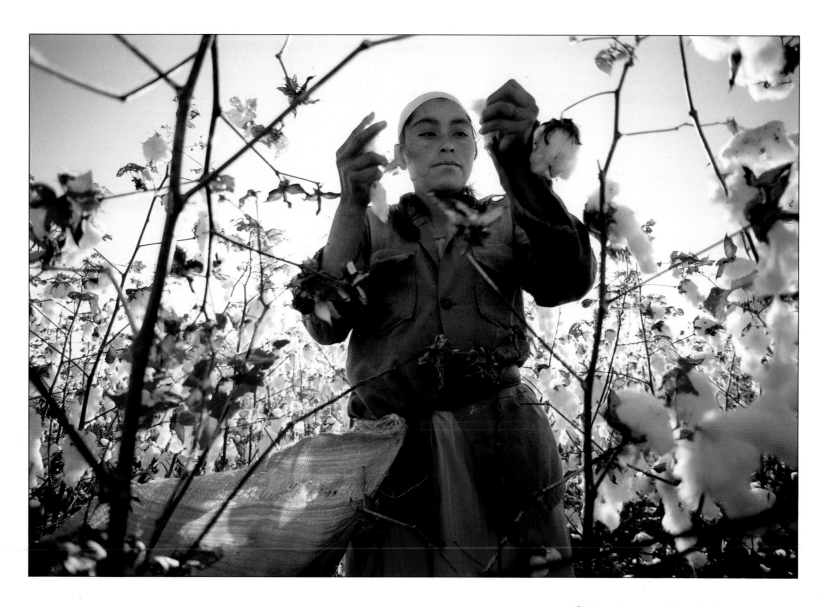

Cotton harvest, Villa del Carmen, 1984.

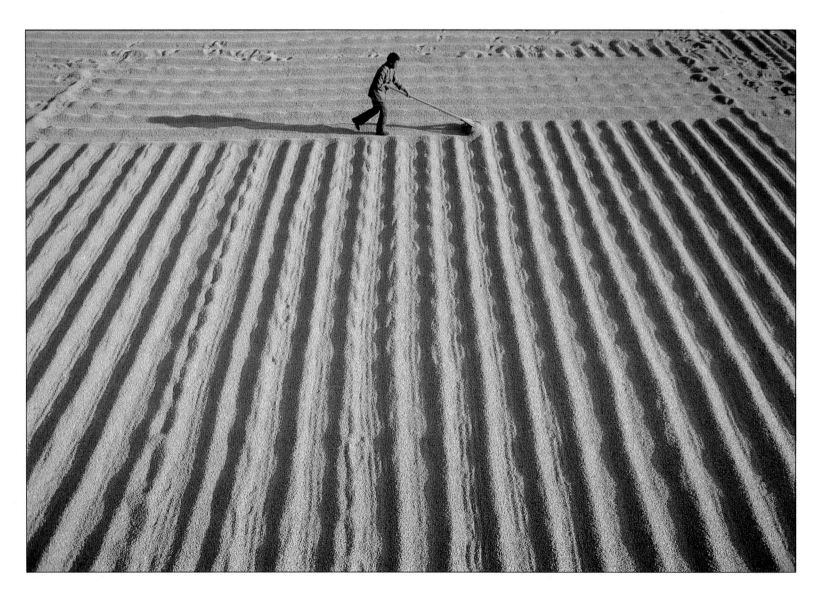

Drying coffee, Matagalpa, 1987.

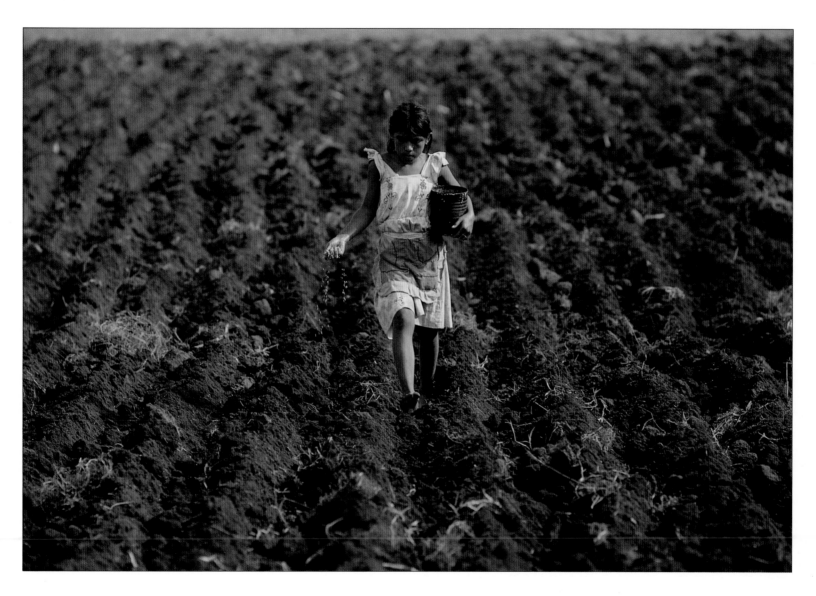

Spreading fertilizer, Granada, 1986.

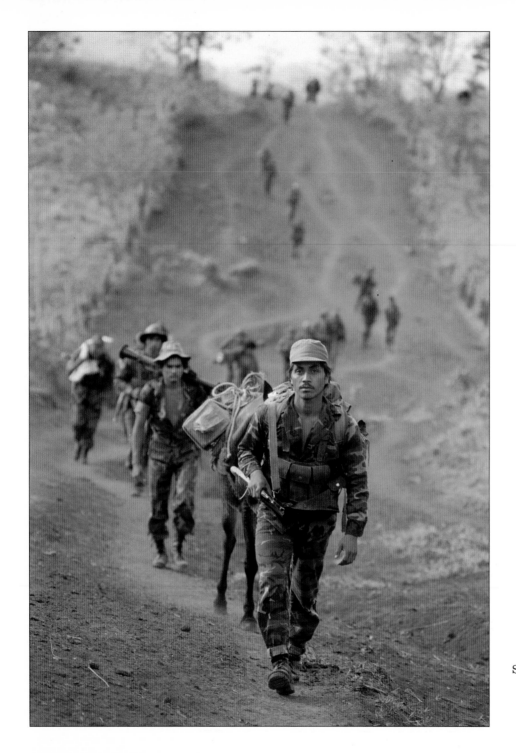

Sandinistas on patrol, Matagalpa Department, 1985.

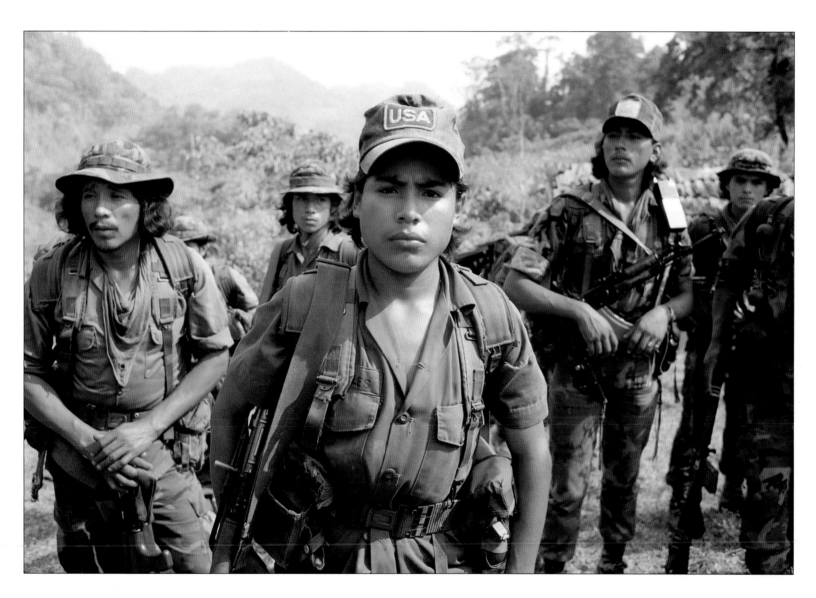

Contras, Jinotega Department, 1987.

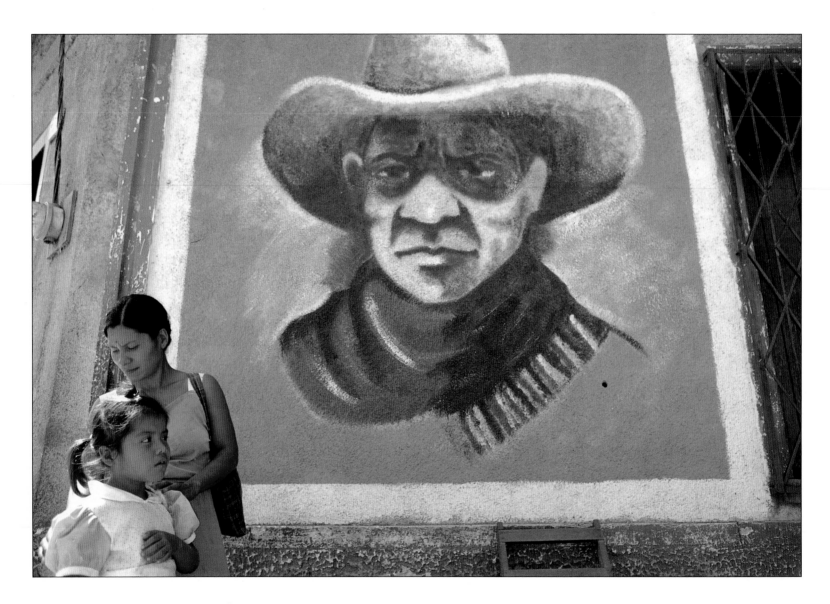

Sandino mural, San Juan del Rio Coco, 1984.

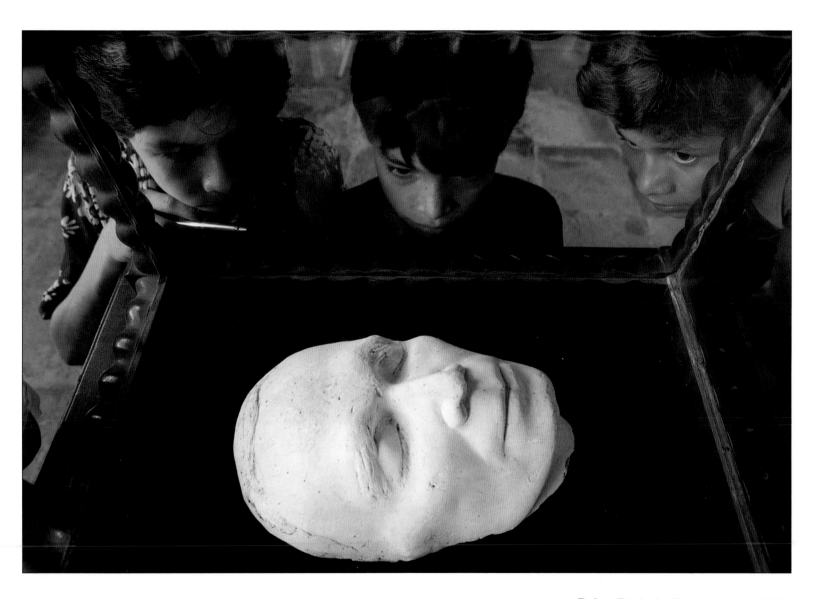

Ruben Dario death mask, Leon, 1988.

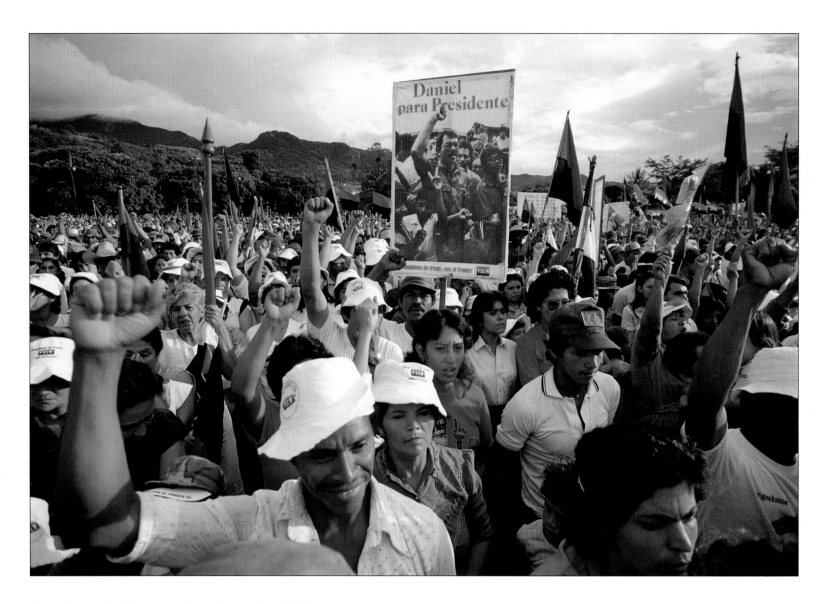

Presidential election campaign, Matagalpa, 1984.

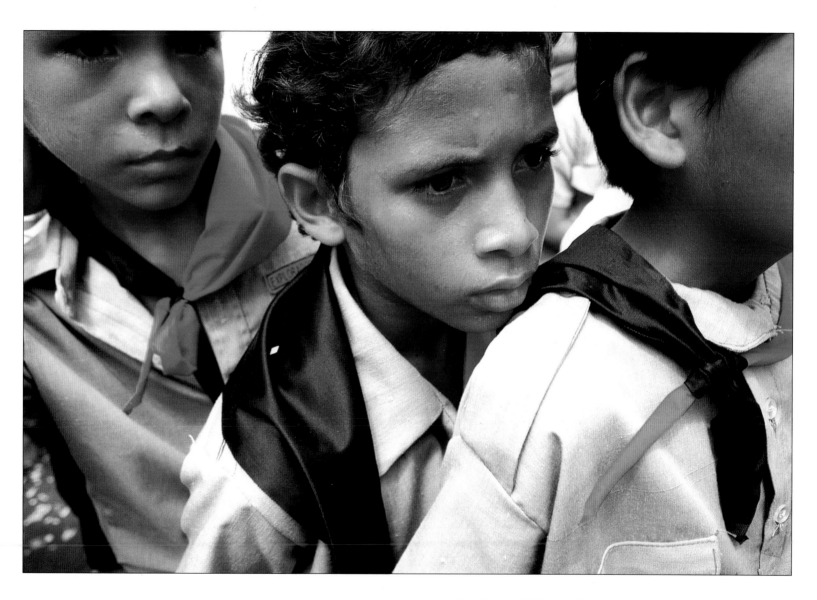

Sandinista Childrens' Association members, Granada, 1988.

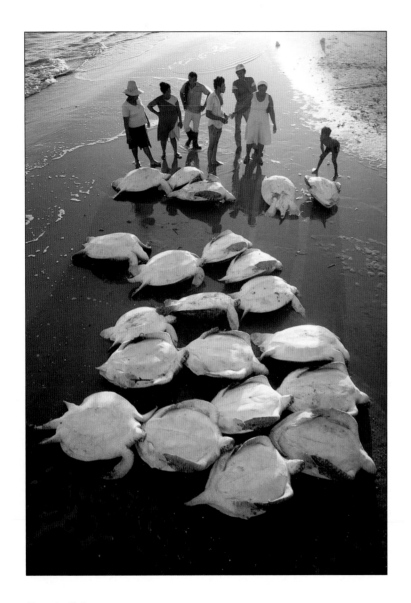

Puerto Cabezas, 1986.

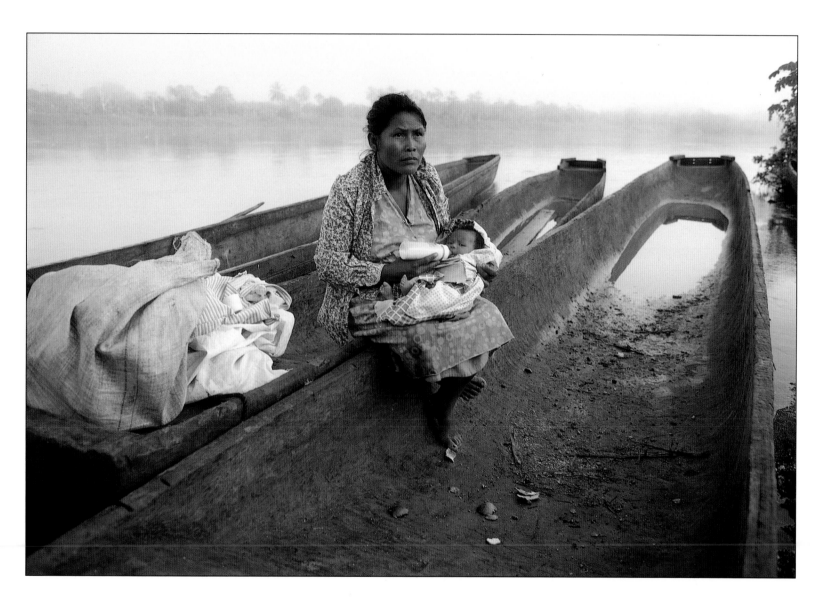

Miskito Indians, Waspam, 1986.

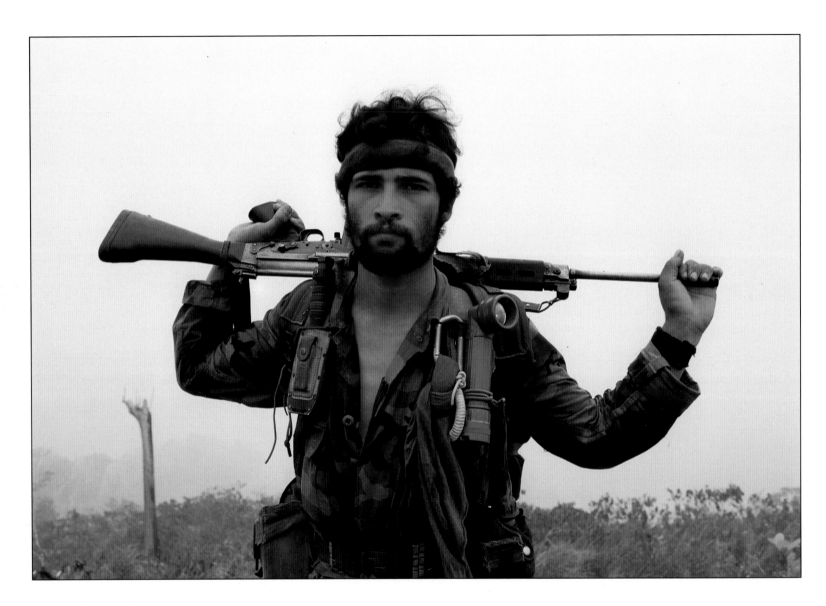

Contra, Jinotega Department, 1987.

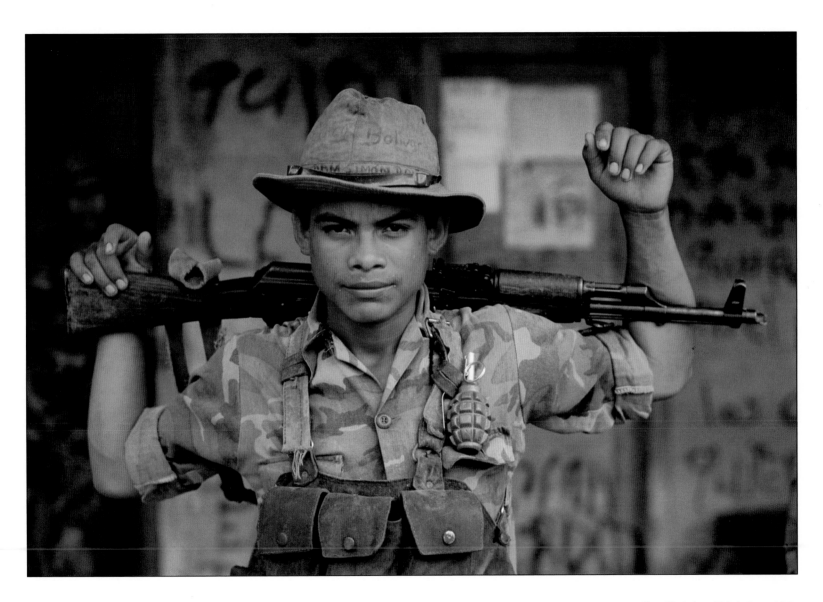

Sandinista, Abisinia, 1985.

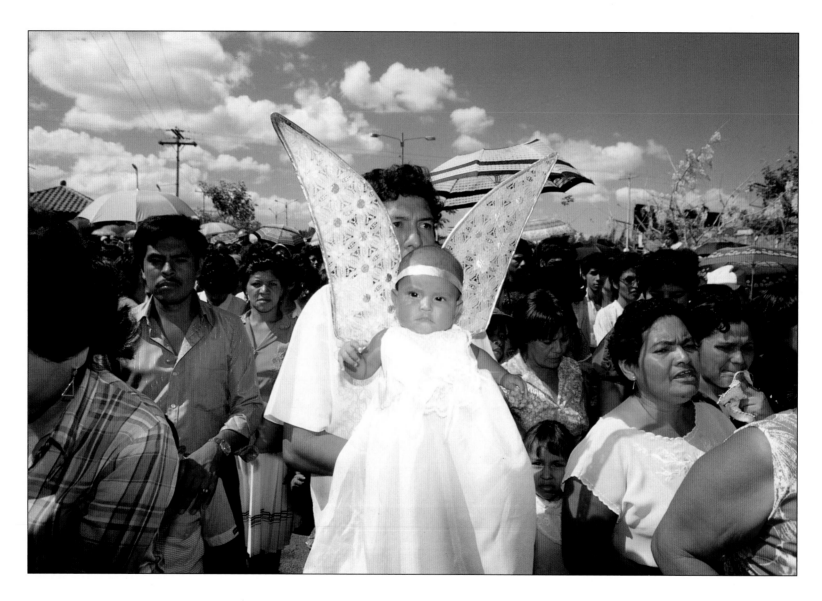

Easter procession, Managua, 1985.

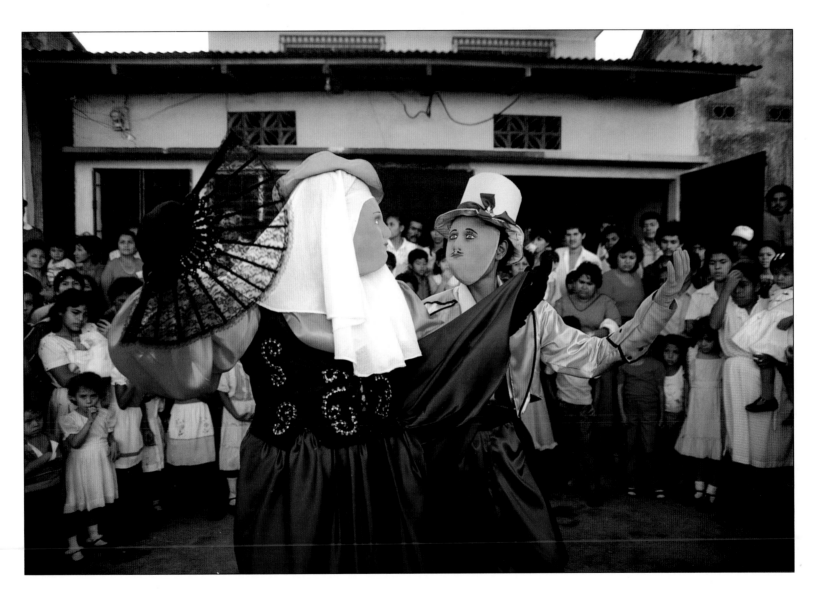

Folkloric dance, Masaya, 1986.

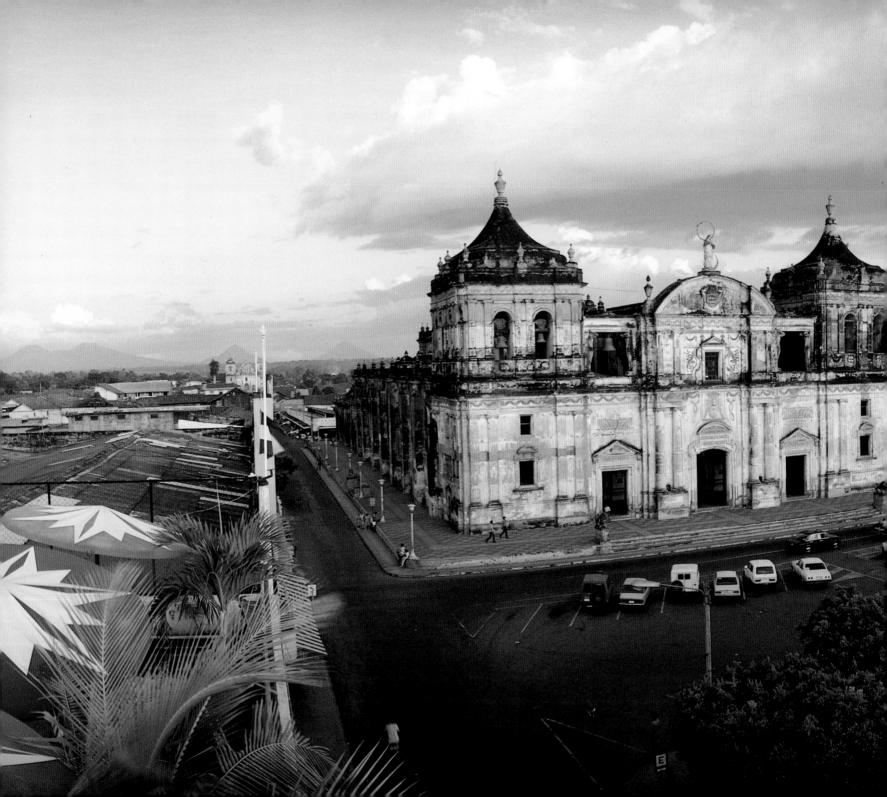

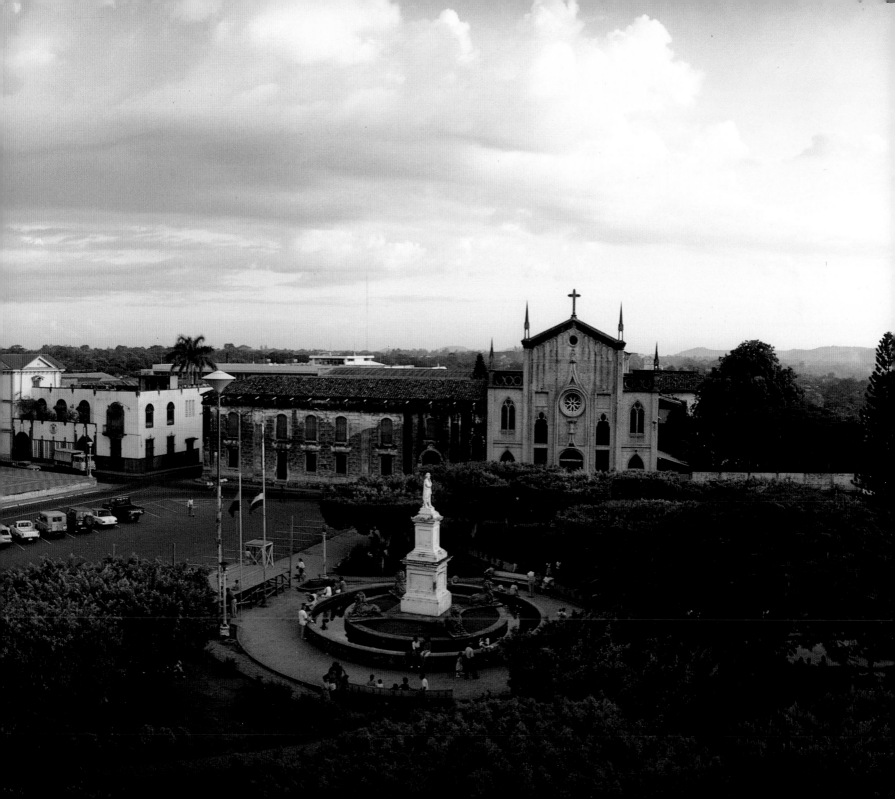

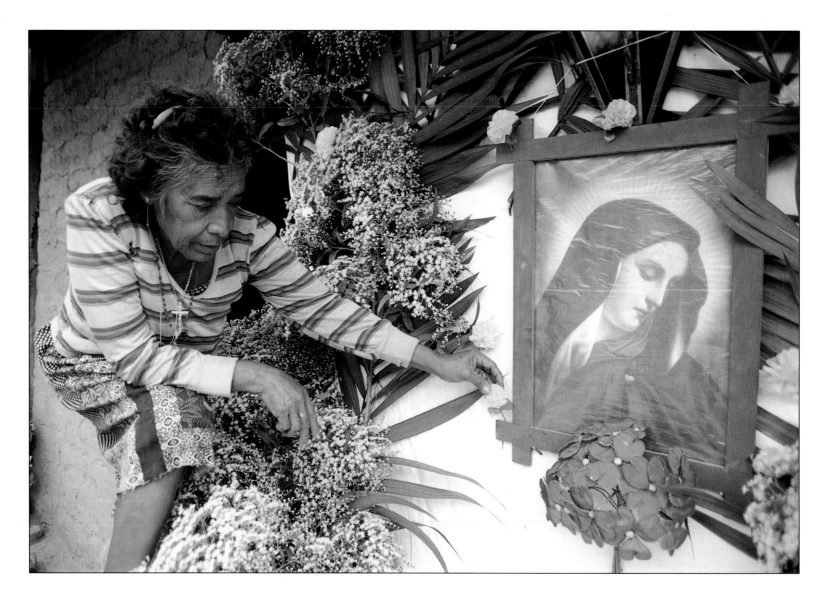

Good Friday, San Juan del Rio Coco, 1988.

Overleaf: Leon, 1988.

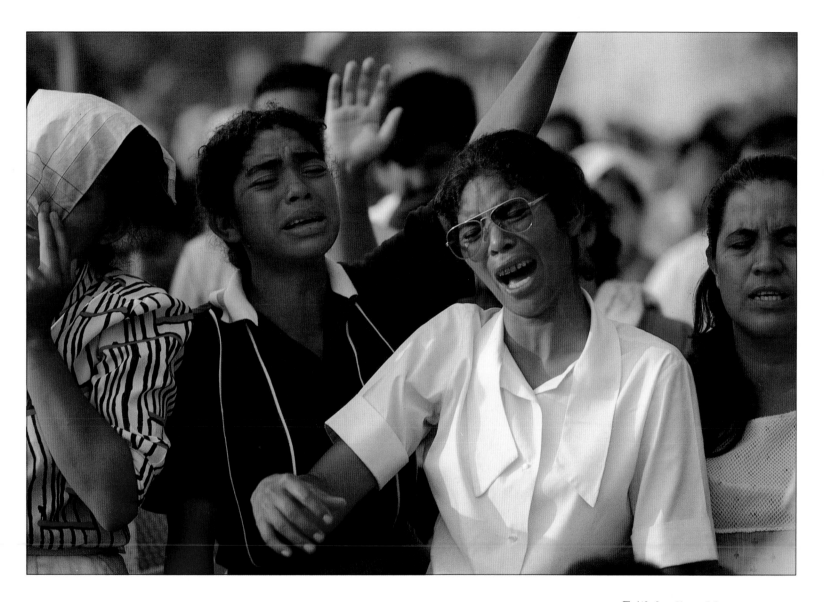

Faith healing, Managua, 1987.

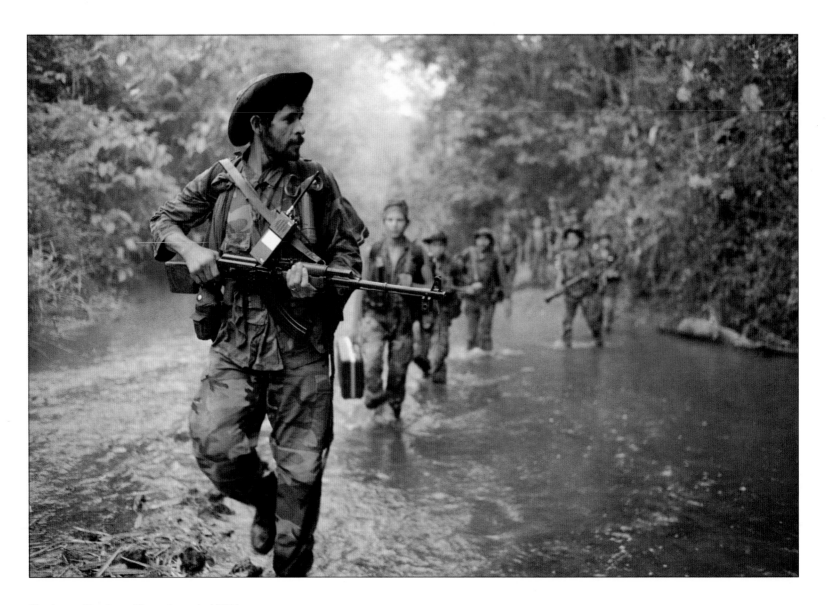

Contras, Jinotega Department, 1987.

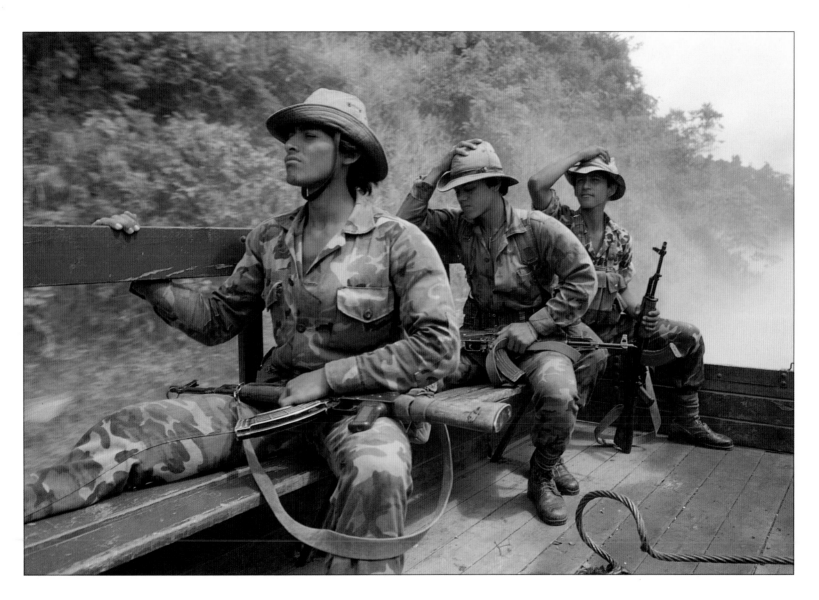

Sandinistas, Jinotega Department, 1987.

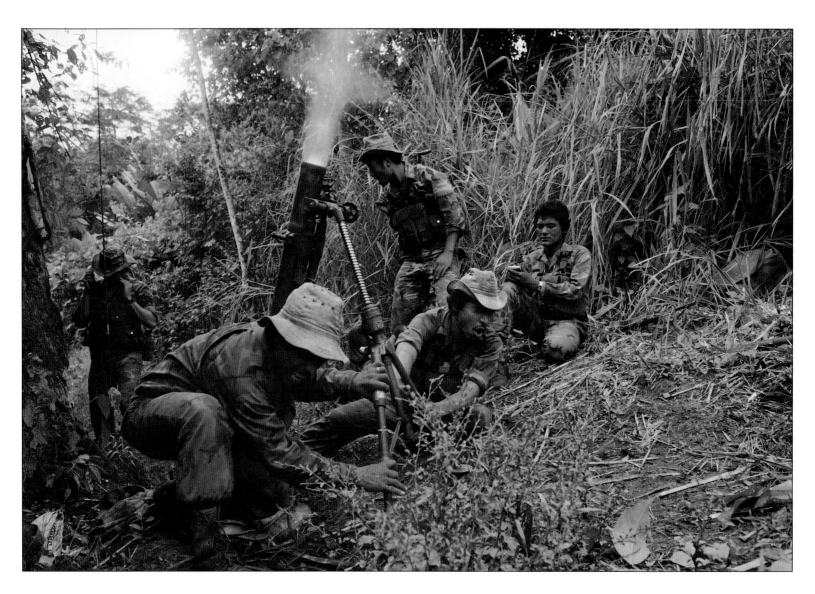

Sandinistas, Jinotega Department, 1985.

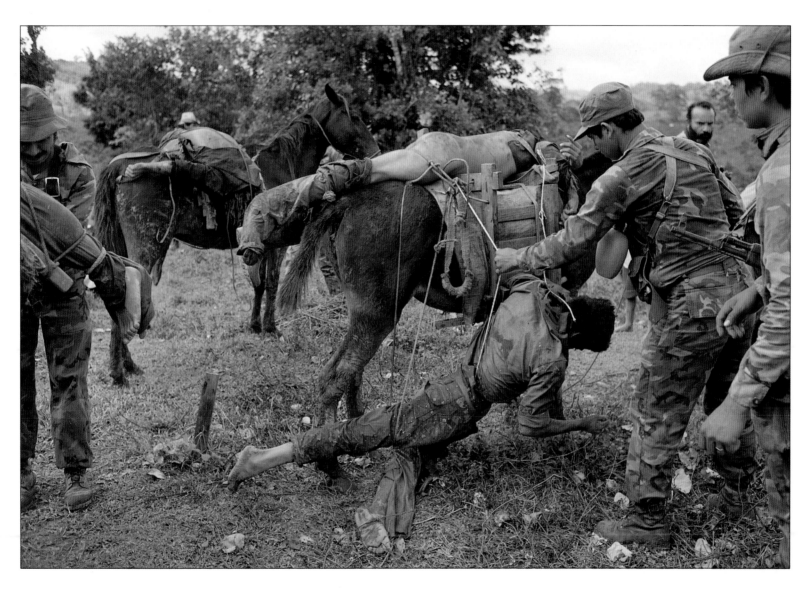

Sandinistas prepare to bury contras, Santo Domingo, 1985.

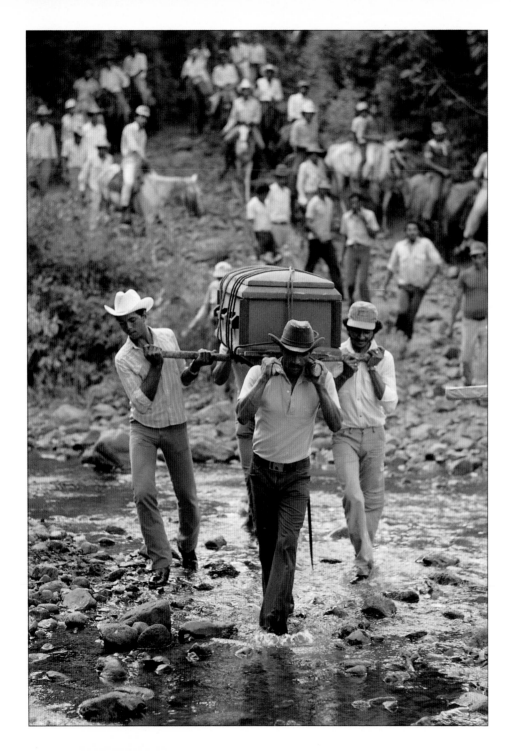

Funeral for civilian voting official killed by contras,
La Labranza, 1984.

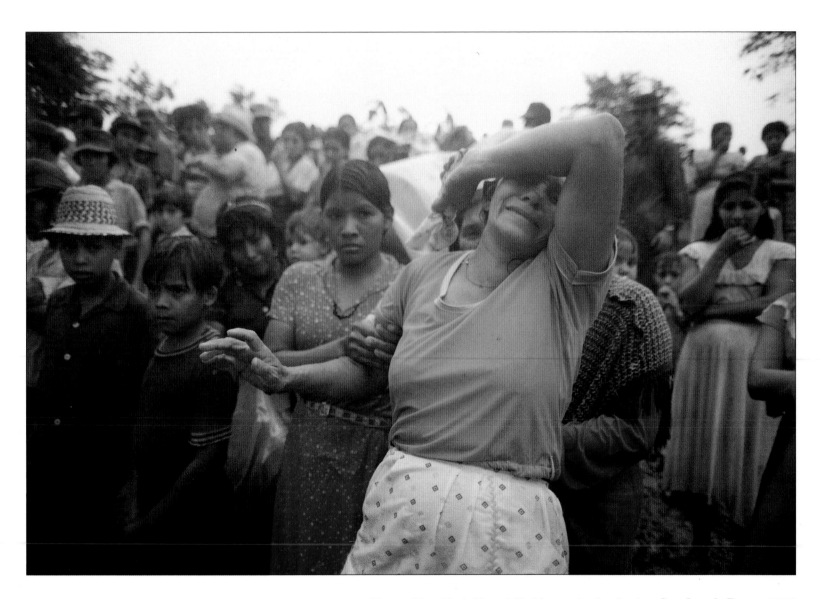

Funeral for 32 civilians killed by contra land mine, San Jose de Bocay, 1986.

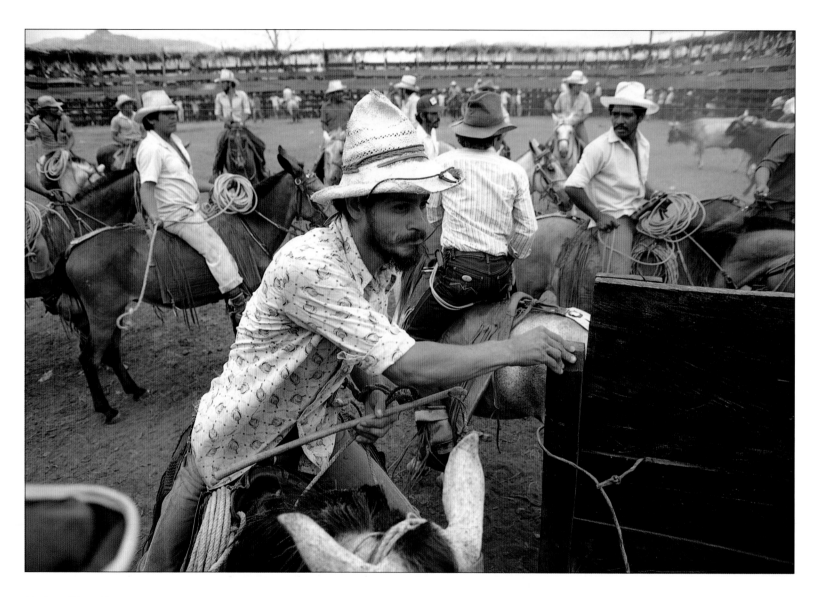

Rodeo, Muy Muy, 1986.

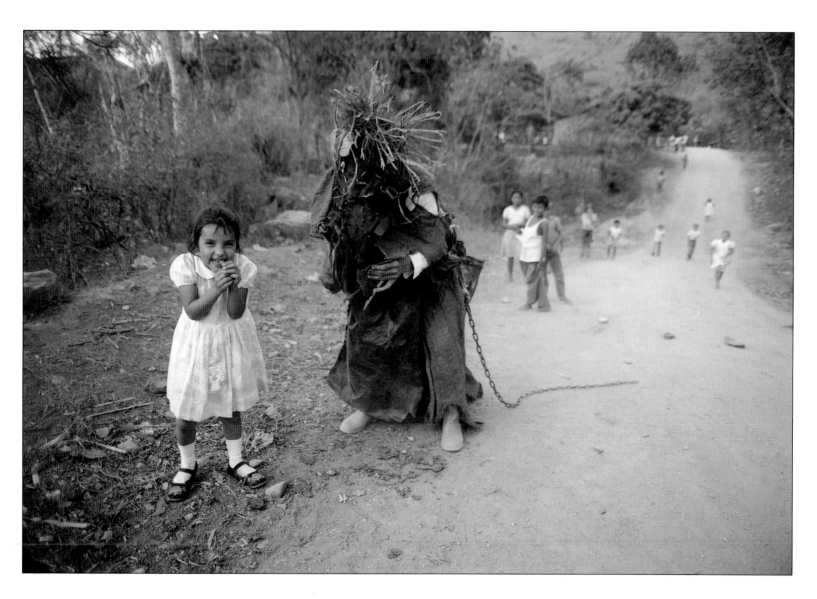

Easter "monster," La Vigia, 1988.

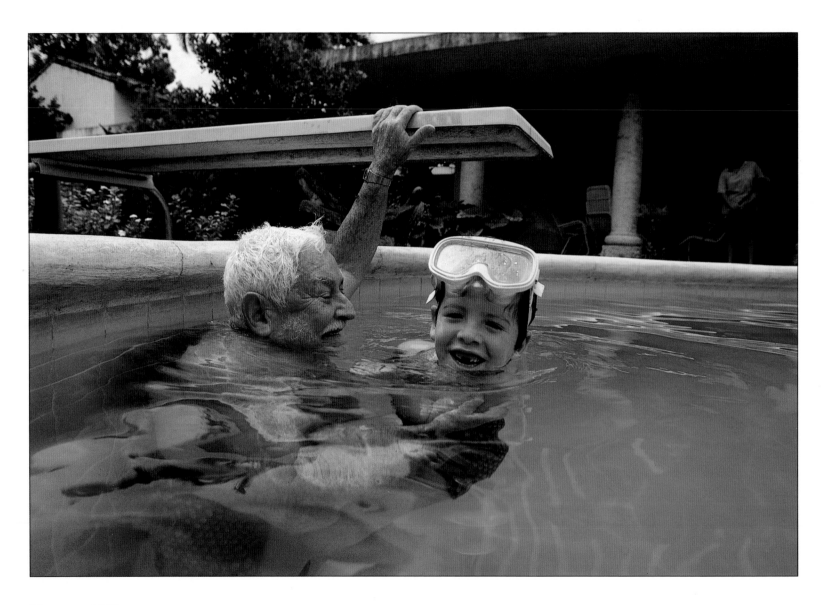

Managua, 1988.

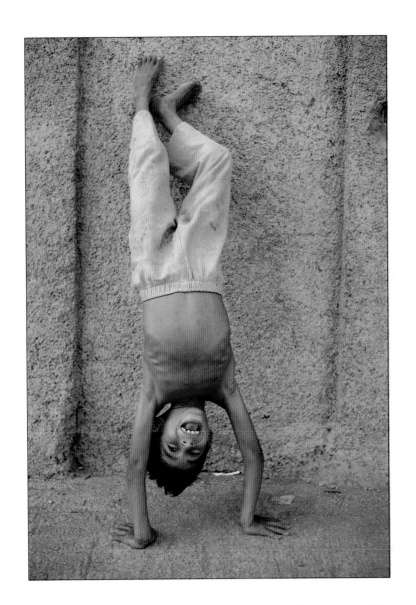

Managua, 1986.

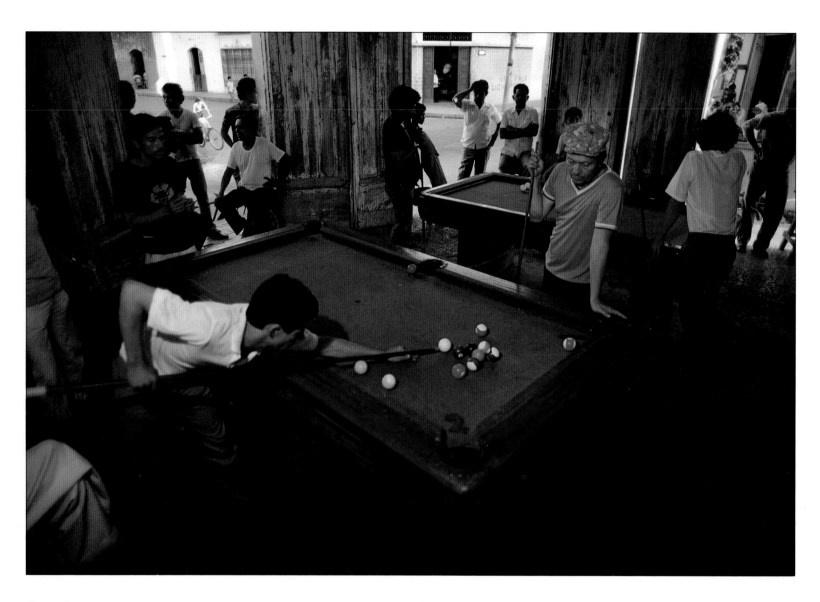

Granada, 1987.

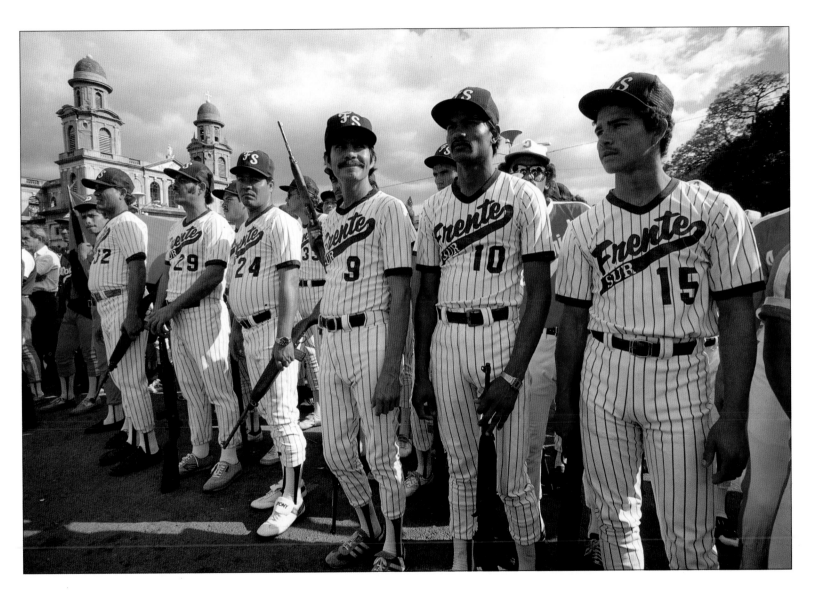

"Southern Front" baseball team, Managua, 1985.

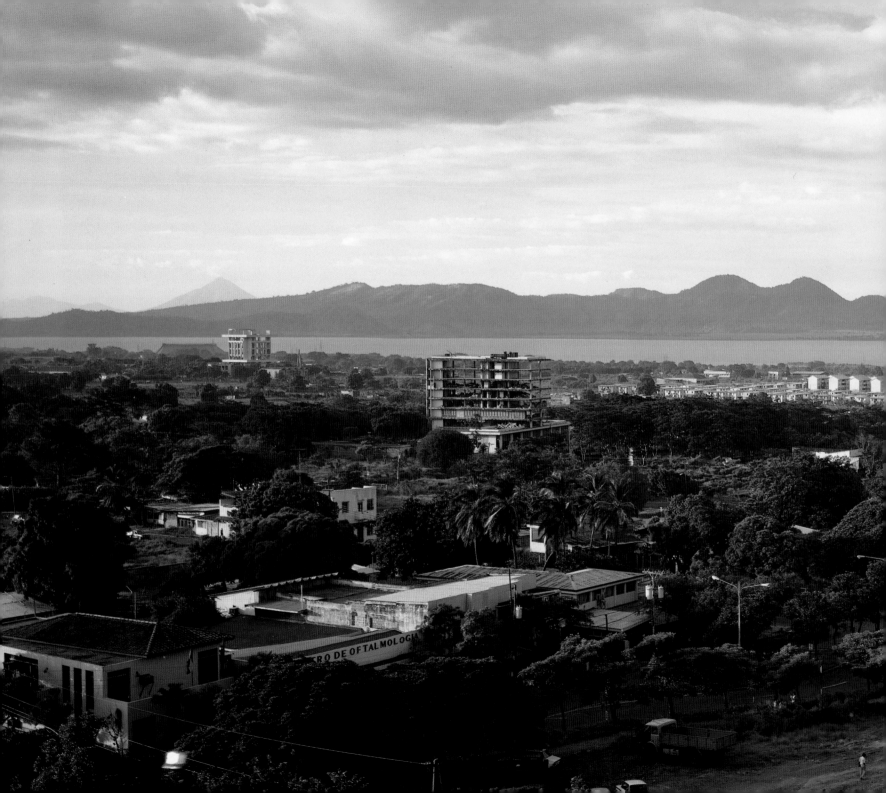

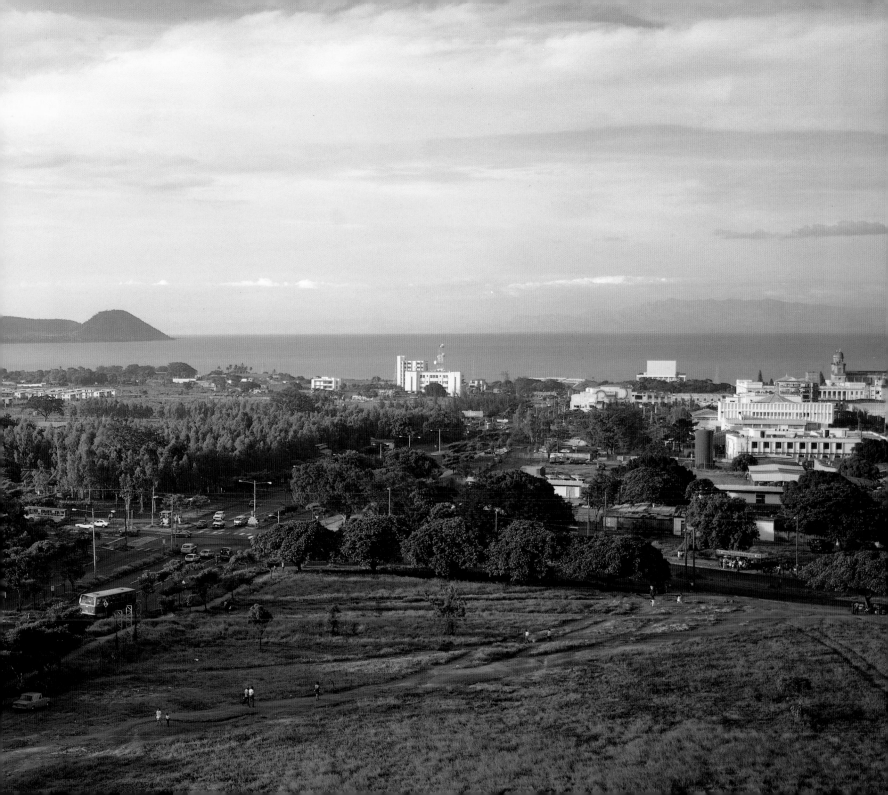

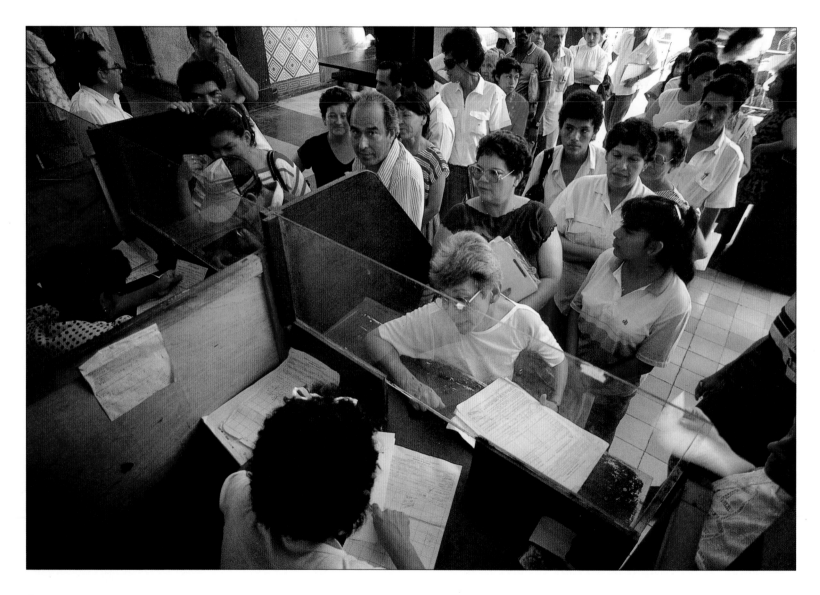

Paying taxes, Managua, 1988.

Overleaf: Managua, 1988.

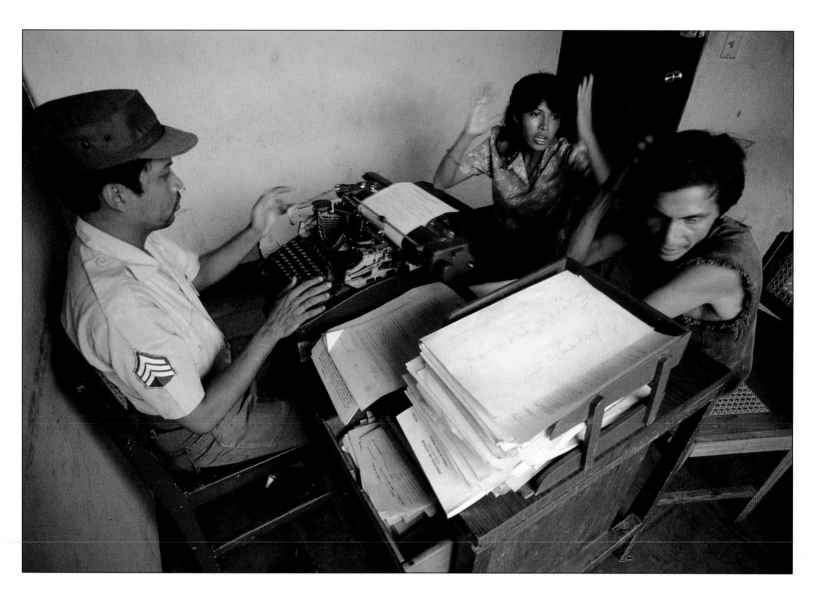

Abused wife presses charges, Managua, 1988.

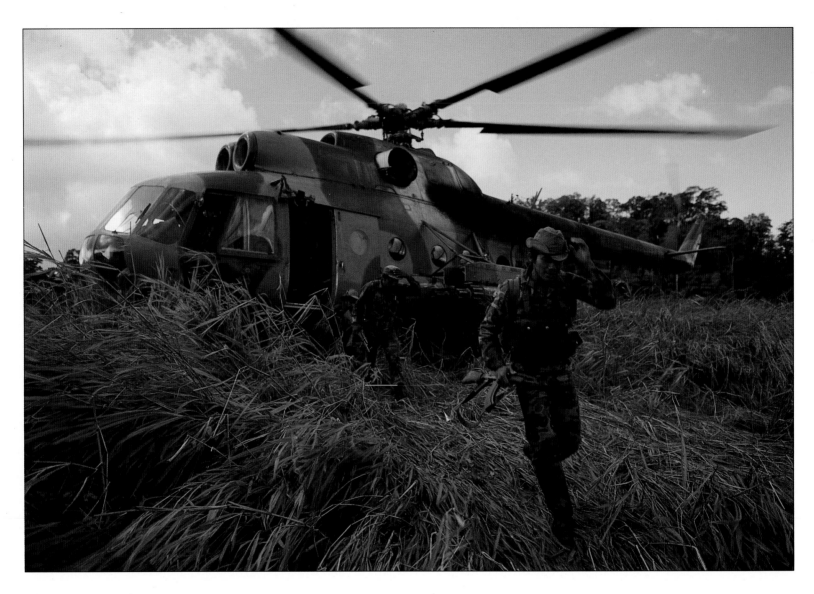

Sandinistas, Jinotega Department, 1985.

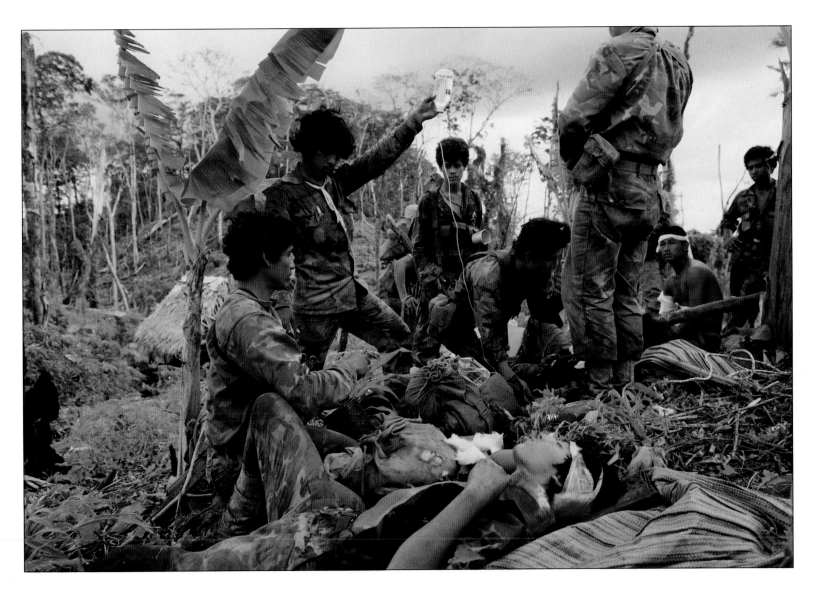

Wounded Sandinistas, Matagalpa Department, 1985.

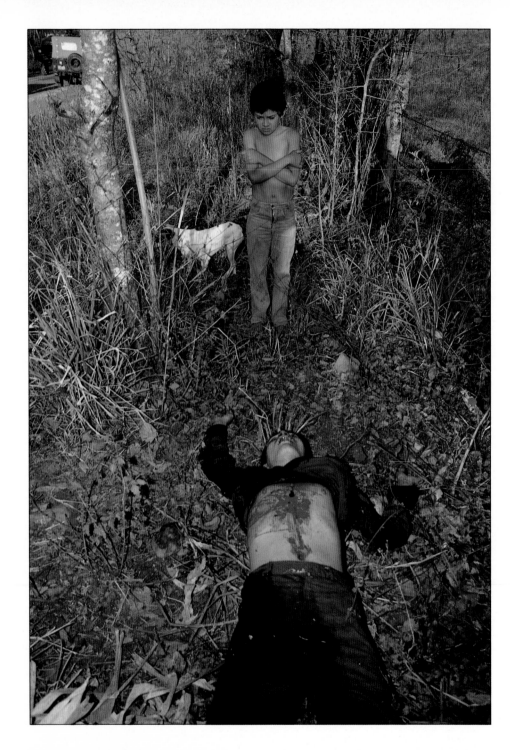

Dead contra, Wiwili, 1986.

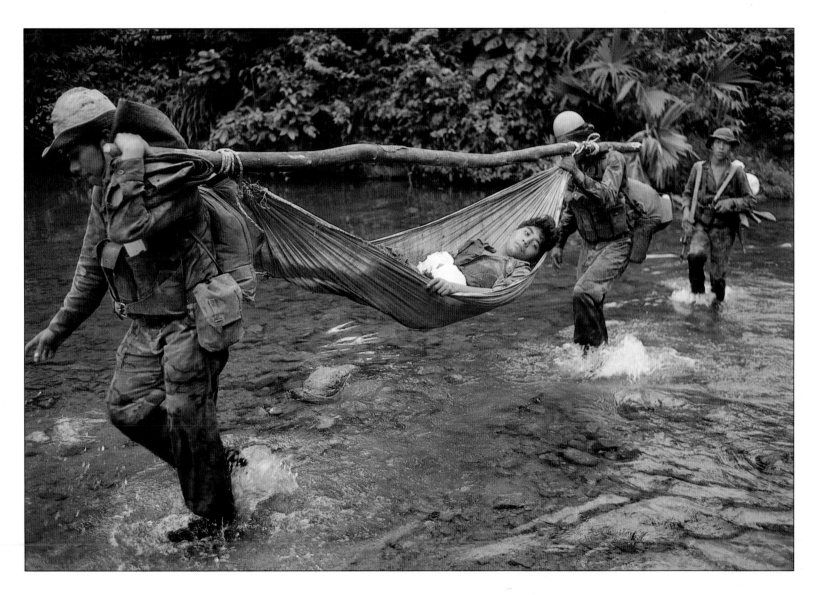

Wounded Sandinista, Matagalpa Department, 1985.

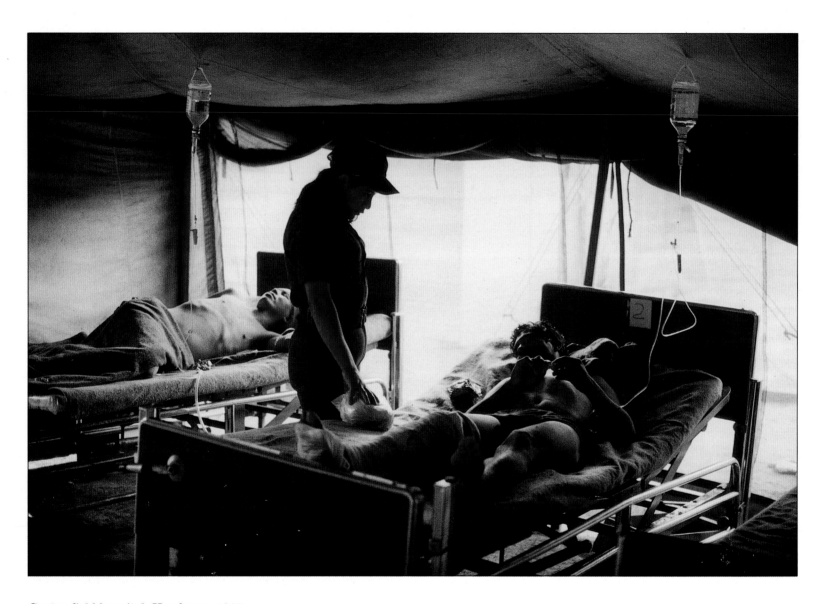

Contra field hospital, Honduras, 1985.

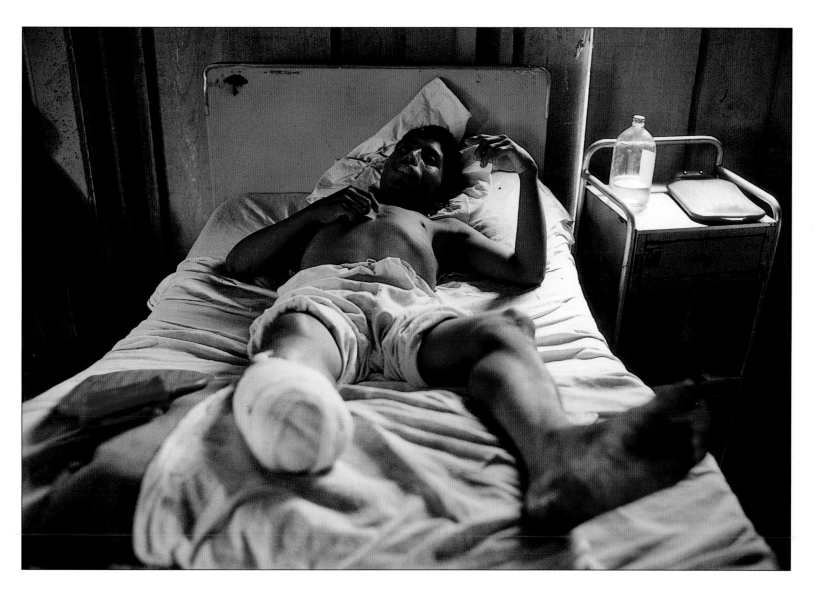

Sandinista military hospital, Apanas, 1987.

Contra, Amaka, 1987.

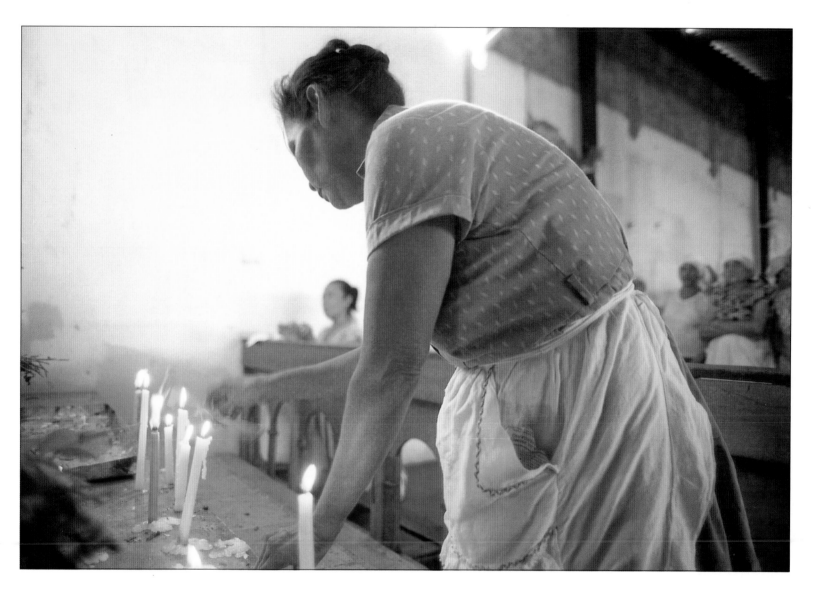

Mothers of political prisoners on a vigil, Managua, 1987.

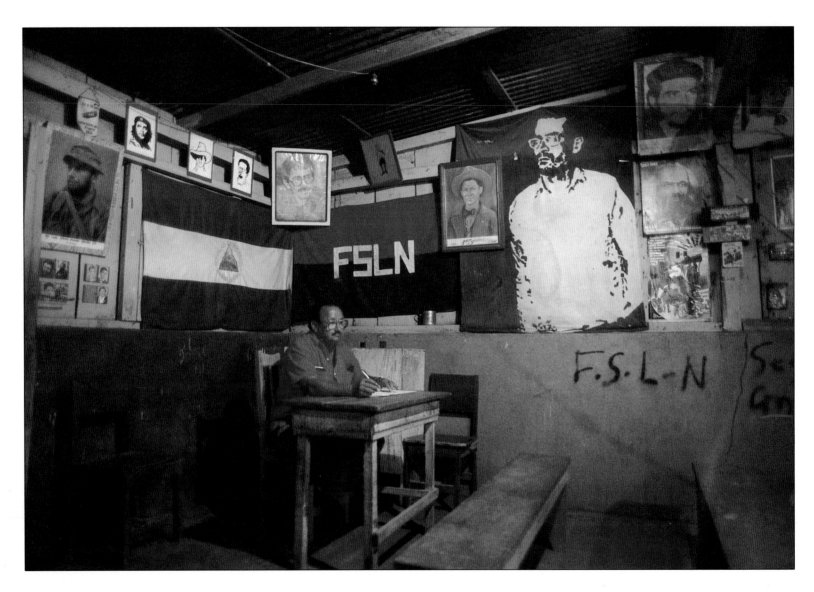

Sandinista Defense Committee office, Managua, 1988.

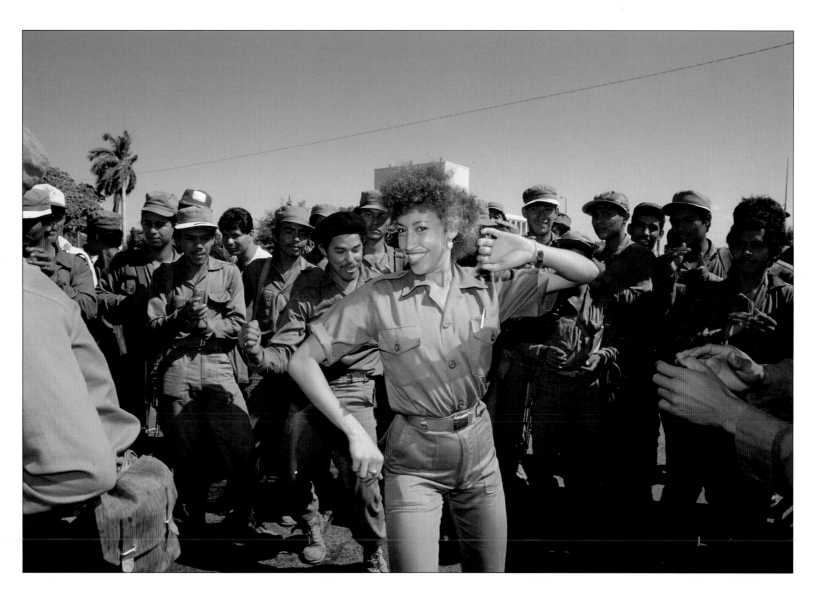

Members Sandinista Popular Army at a rally, Managua, 1986.

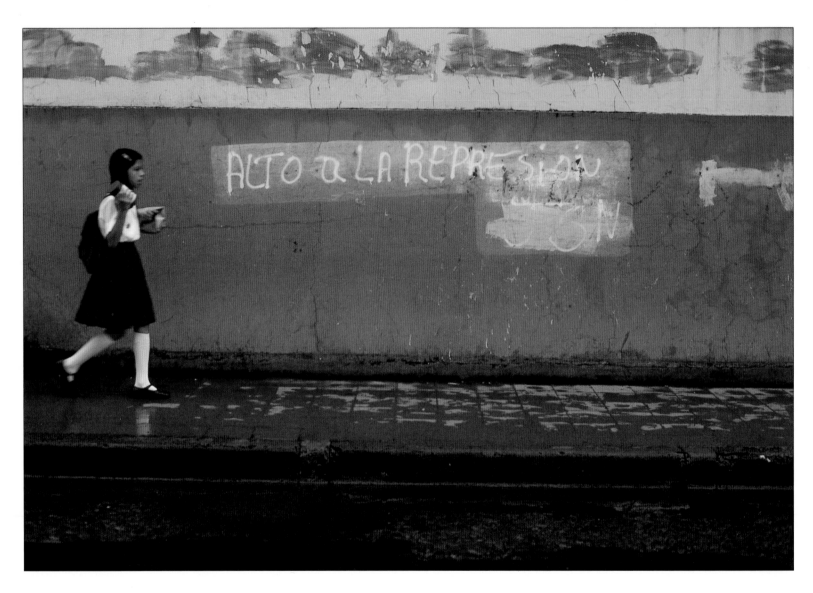

"Stop the Repression," Leon, 1988.

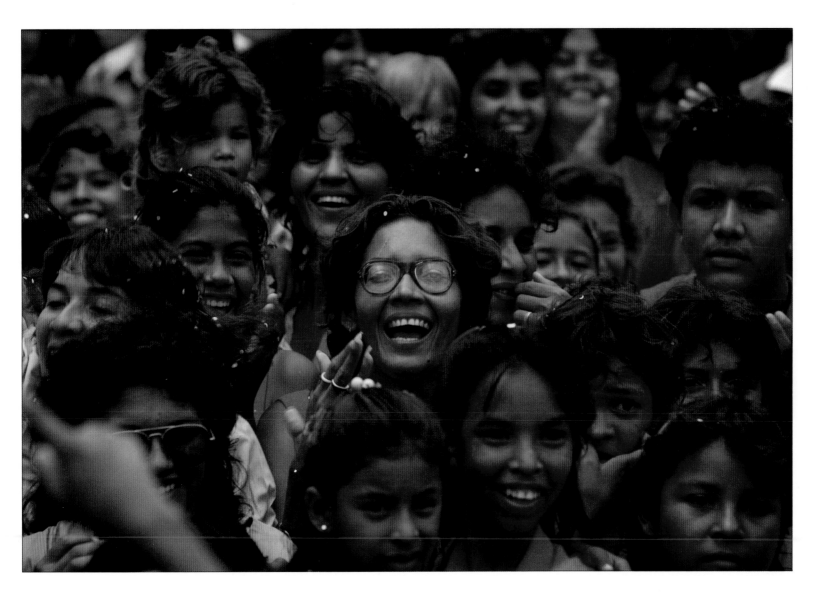

Beauty contest, Granada, 1988.

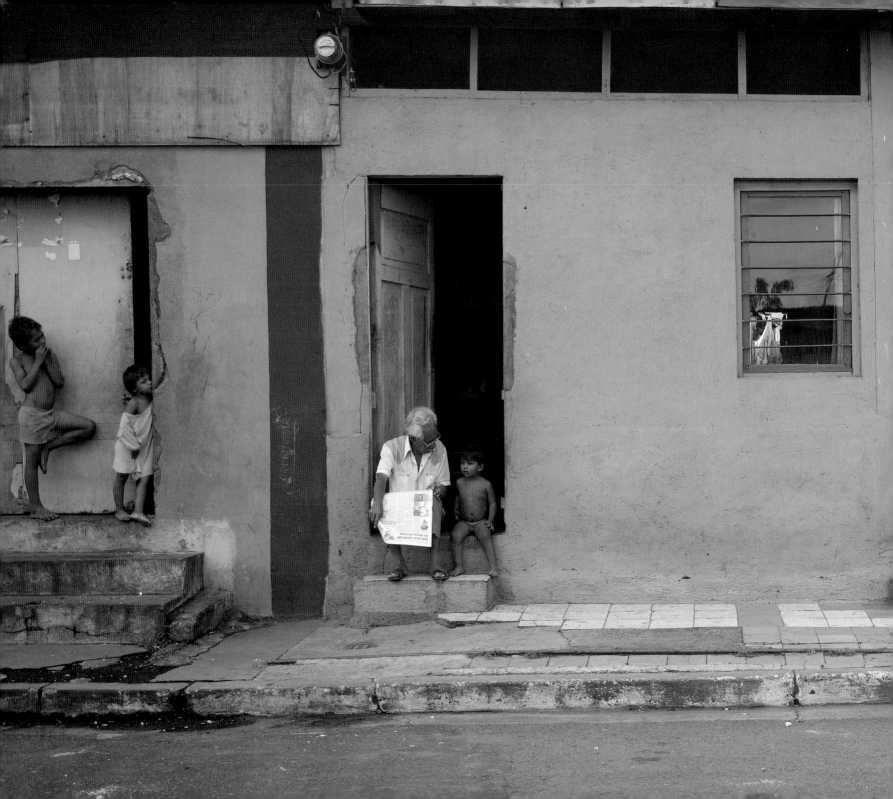

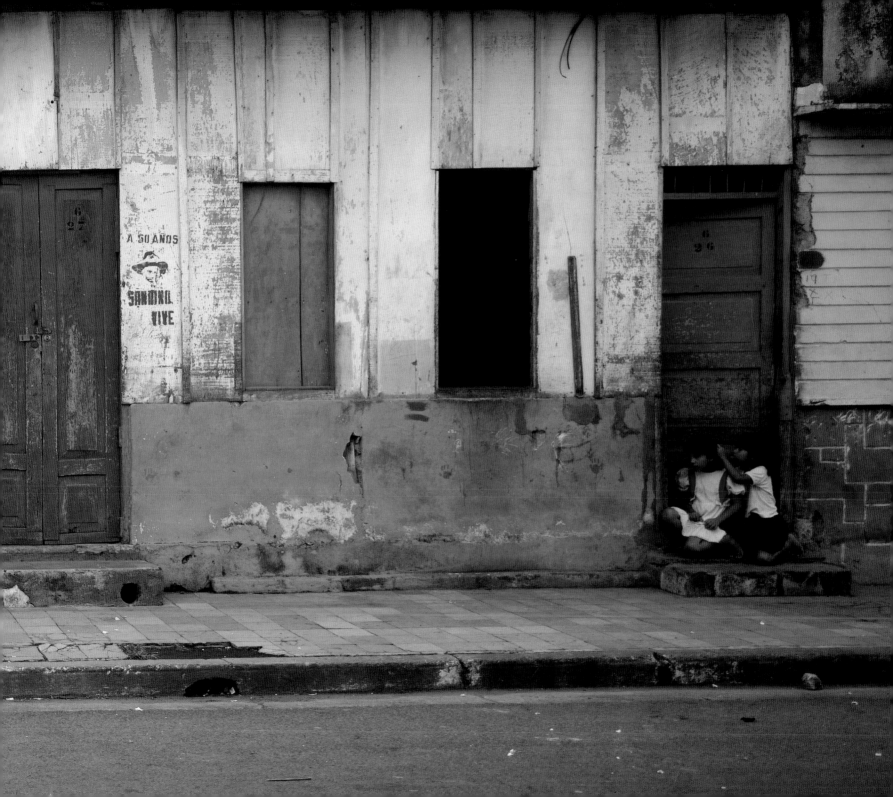

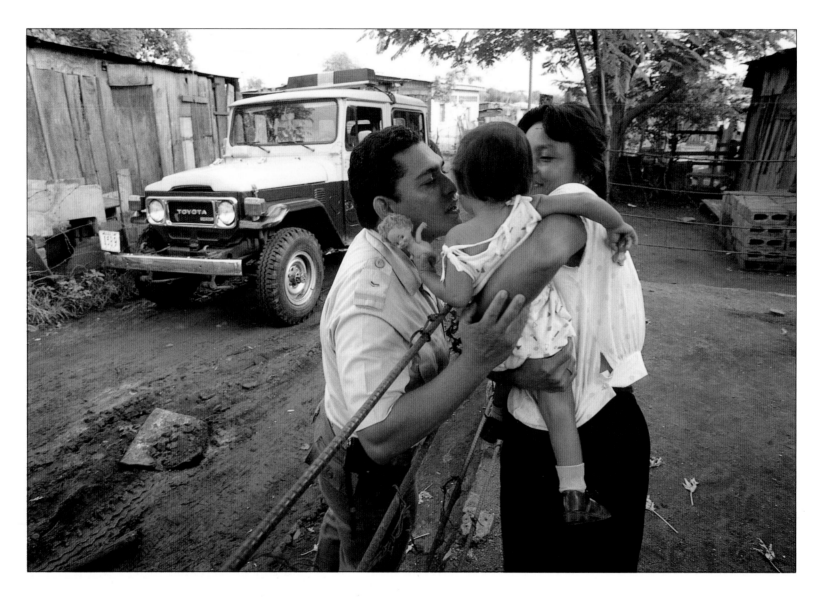

Sandinista policeman with his family, Managua, 1988.

Overleaf: Managua street scene, 1988.

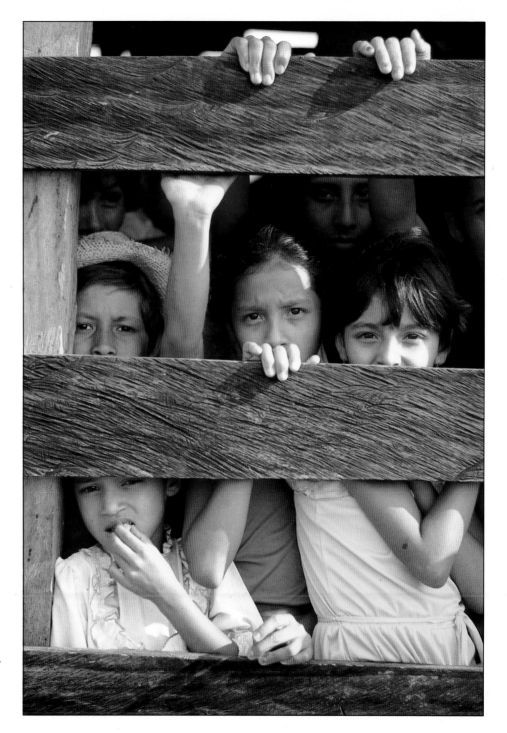

Rodeo, Muy Muy, 1986.

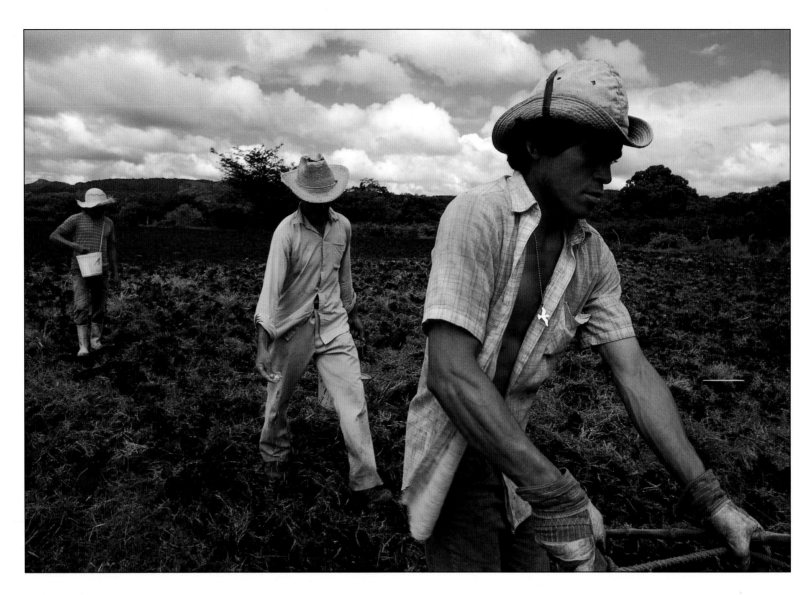

Salvadoran war refugees at a Sandinista donated cooperative, Esteli, 1988.

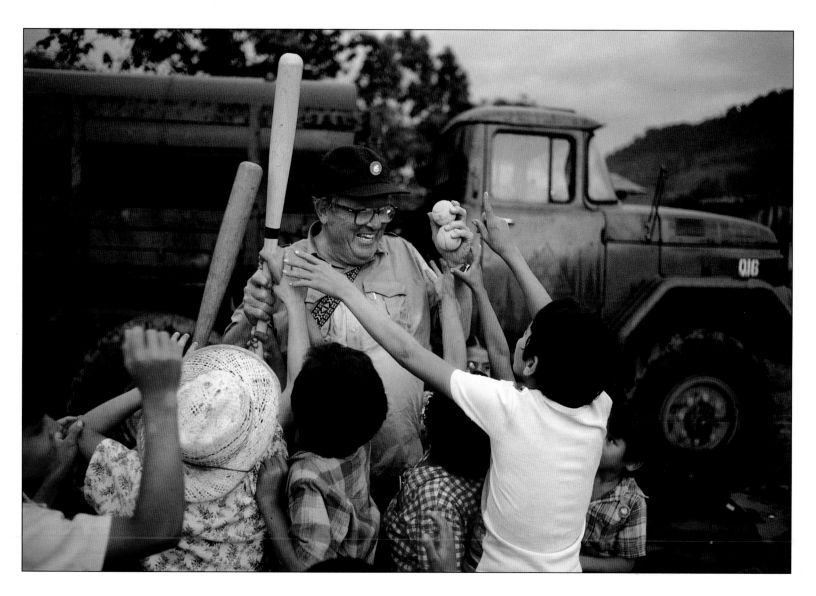

American opponent of Reagan policy, San Jose de Bocay, 1987.

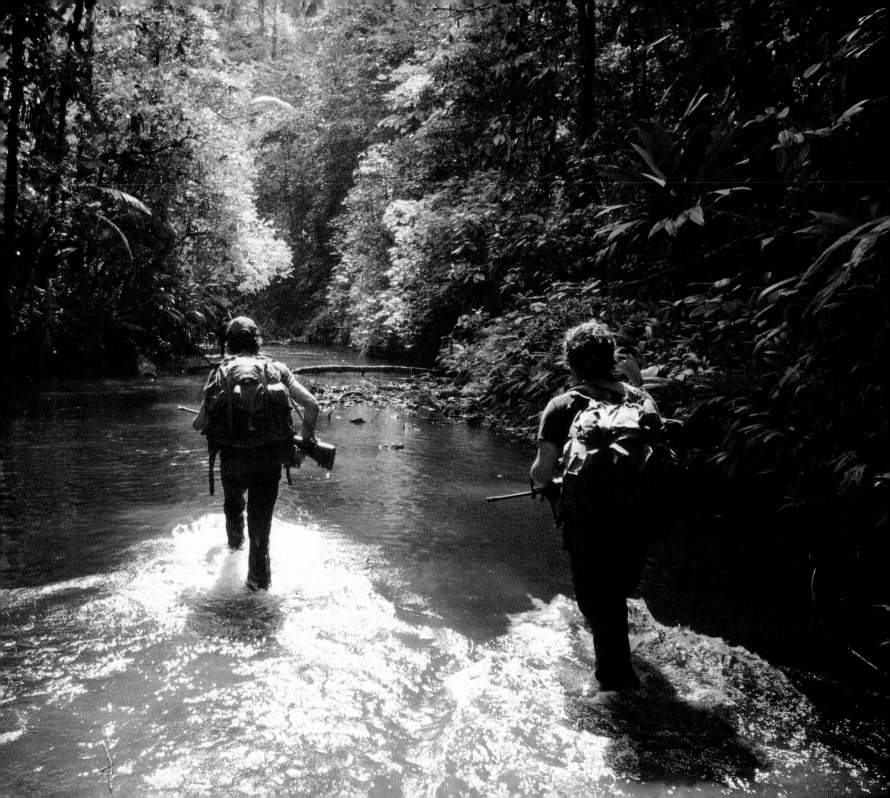

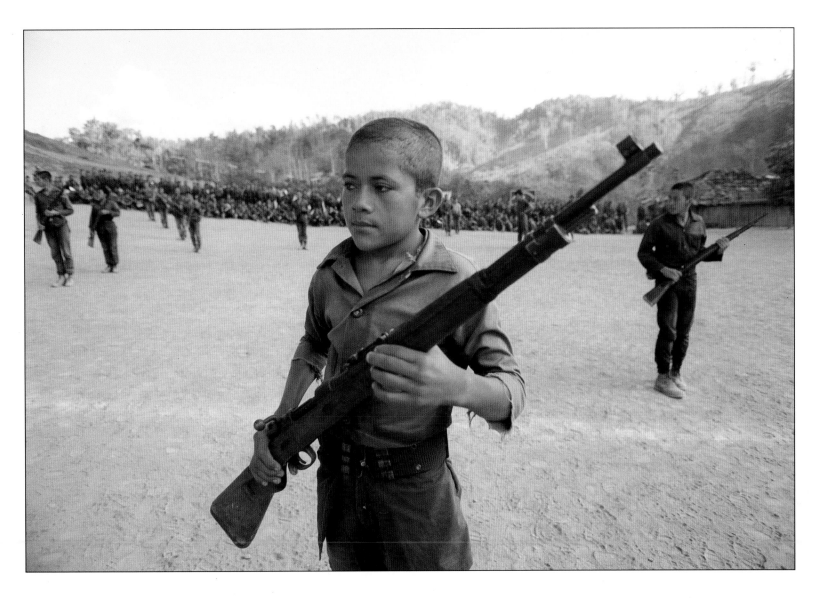

Opposite: Contras, San Juan River, 1984.

Contras training, Honduras, 1986.

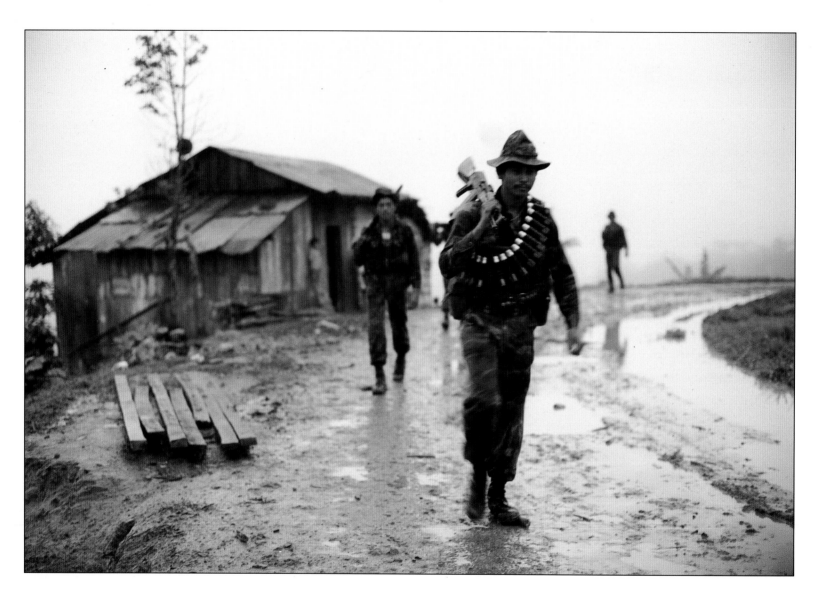

Sandinistas on patrol, Pantasma, 1986.

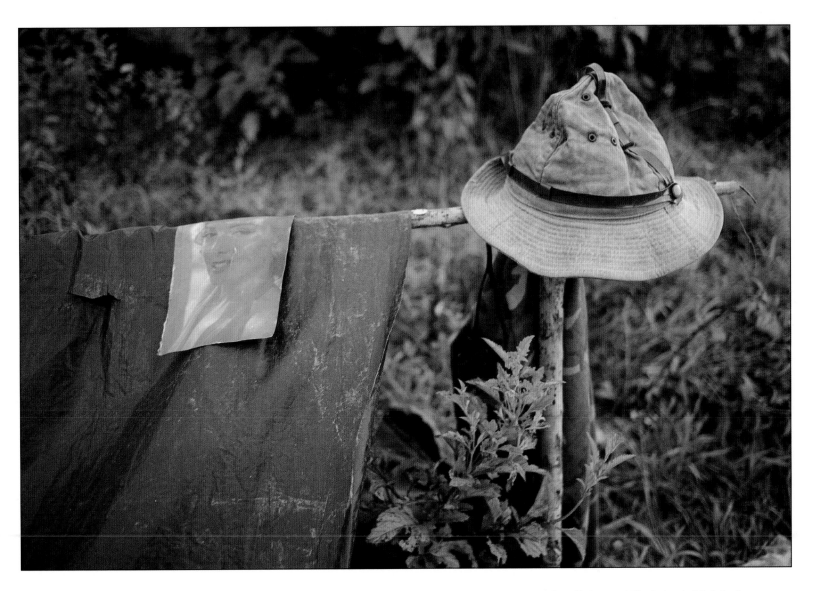

Sandinista soldier's tent, Mulukuku, 1985.

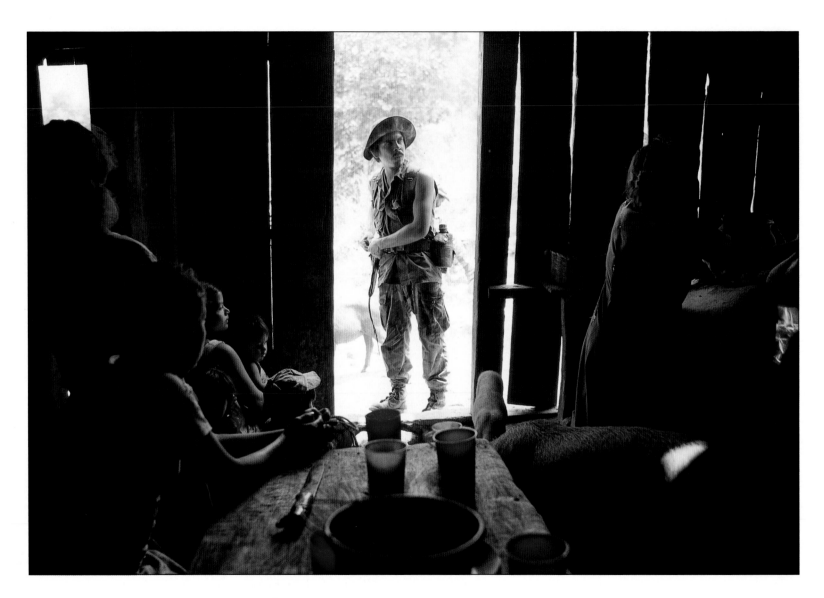

Contra arrives at a peasant's hut, Jinotega Department, 1987.

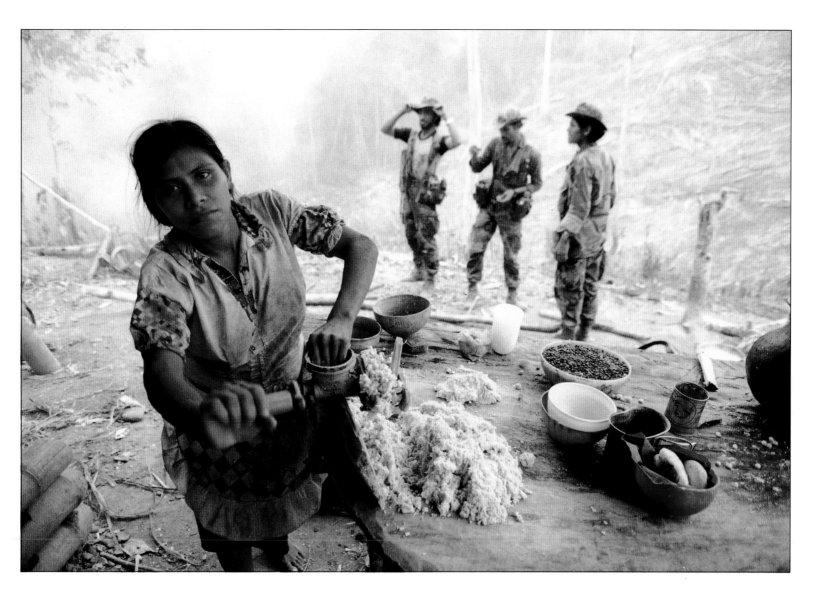

Peasant prepares food for contras, Jinotega Department, 1987.

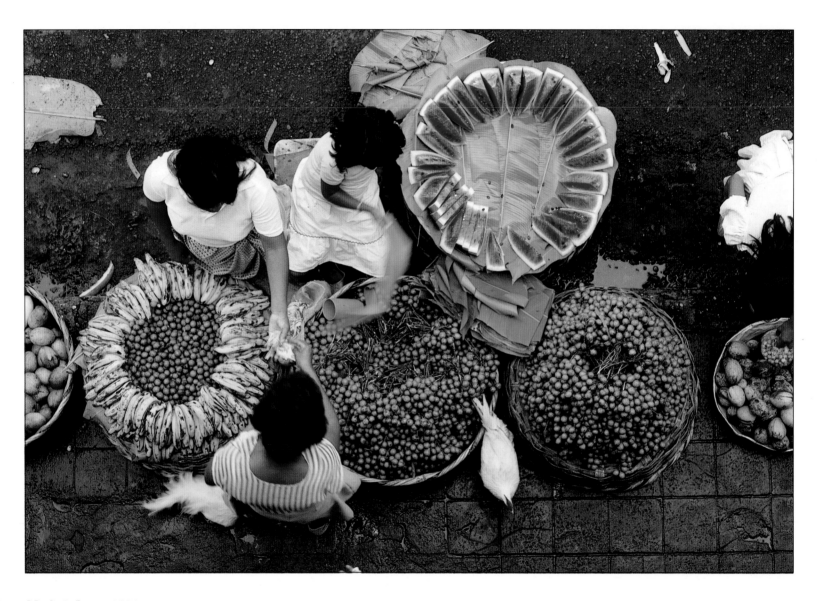

Market, Leon, 1988.

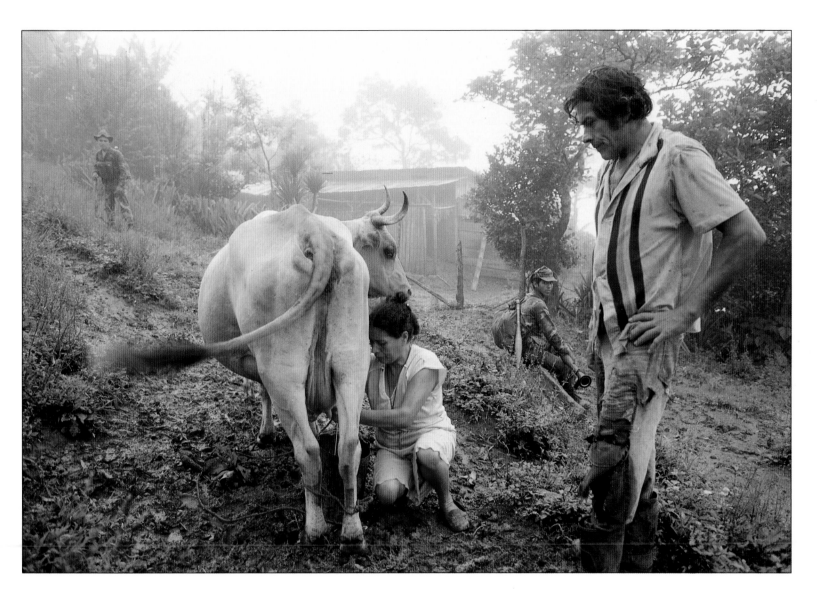

Peasants, Sandinistas on patrol, Matagalpa Department, 1986.

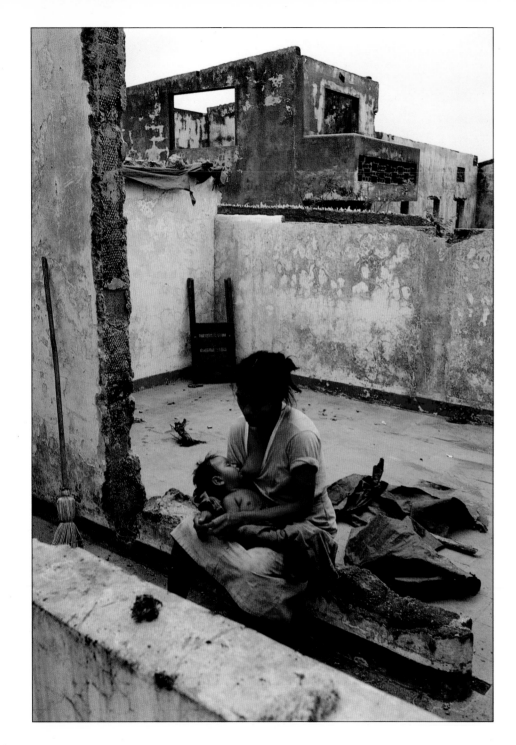

Las Nubes, 1988.

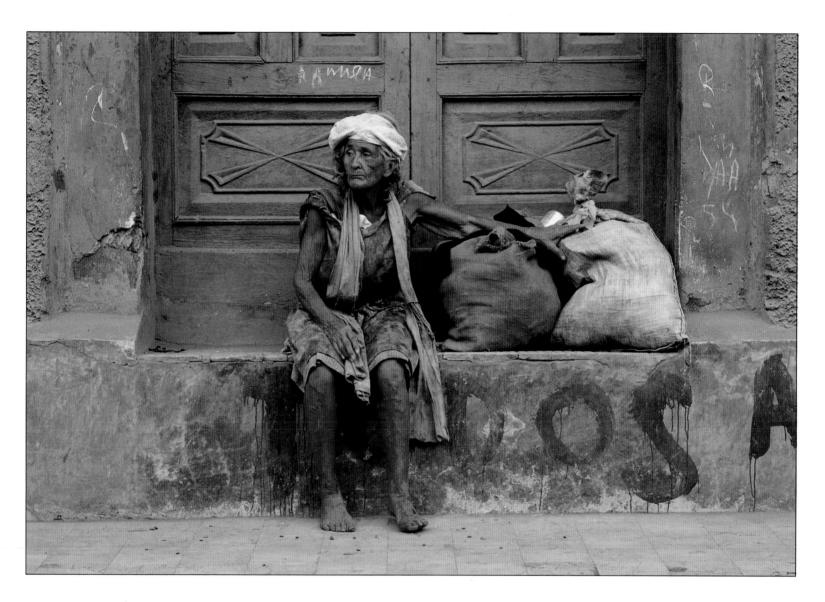

Bag woman, Masaya, 1987.

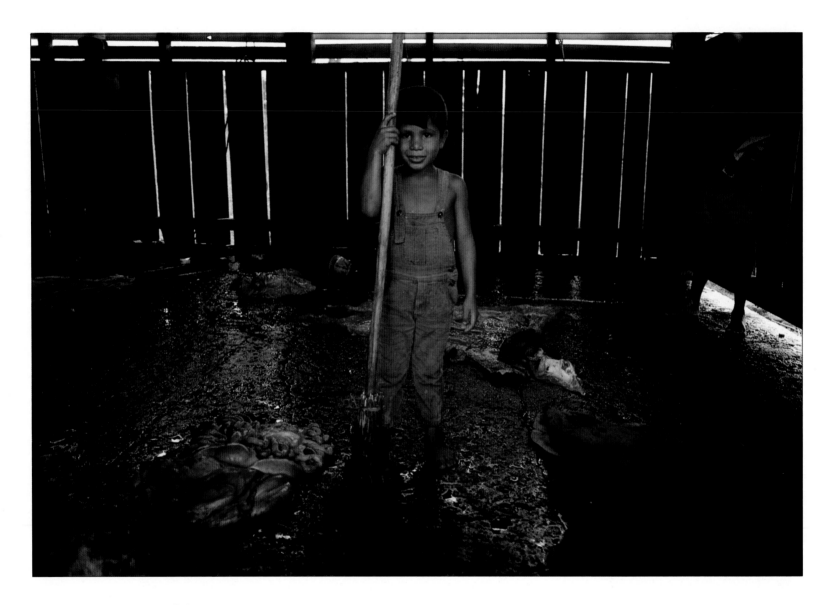

Slaughterhouse, Puerto Cabezas, 1986.

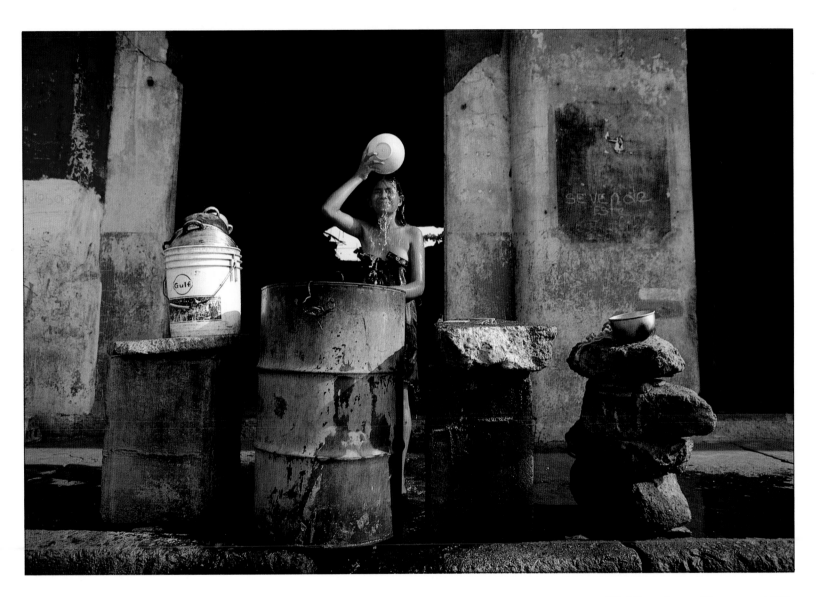

Miskito refugee, Managua, 1986.

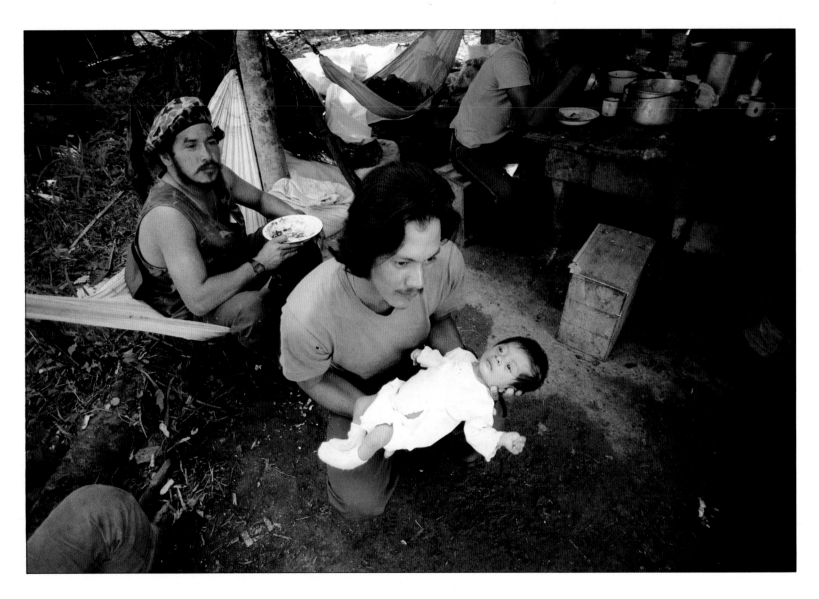

Contra father, San Juan River, 1984.

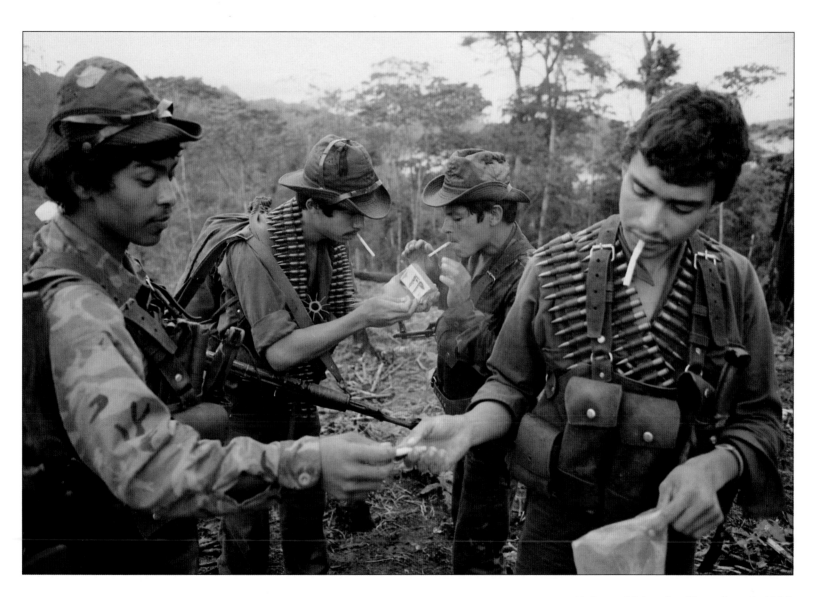

Sandinistas, Matagalpa Department, 1984.

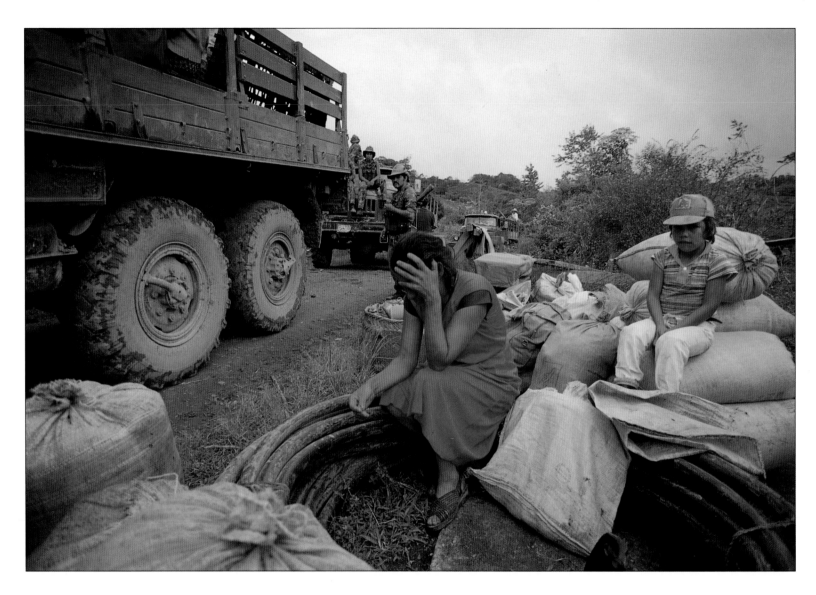

Sandinistas force peasant evacuation, El Ventarron, 1985.

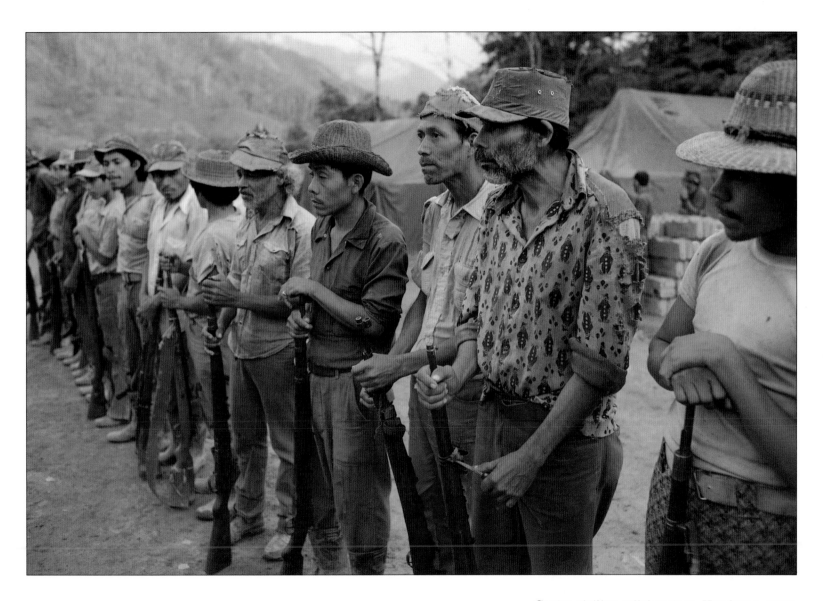

Contra civilian collaborators, Honduras, 1985.

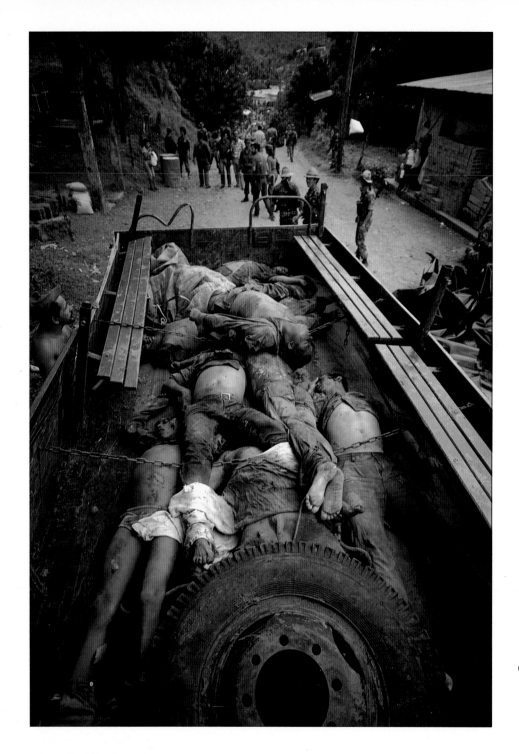

Contras on the way to a burial, Santo Domingo, 1985.

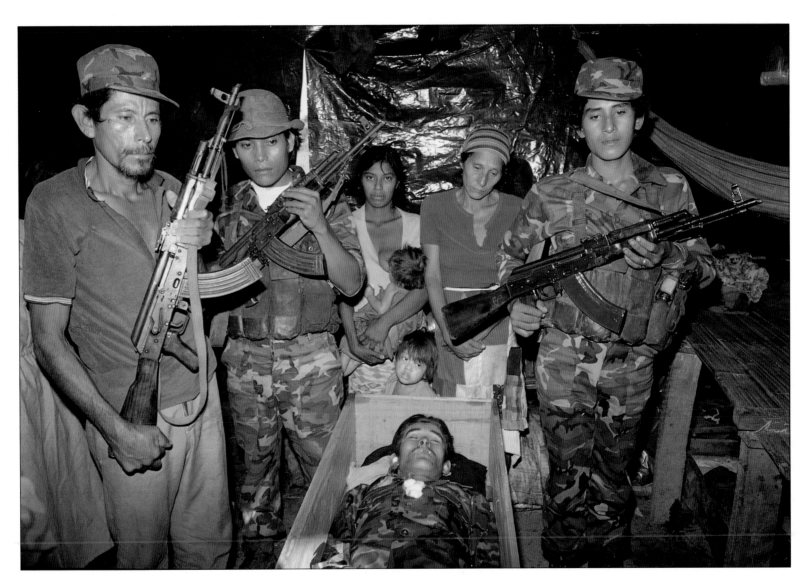

Sandinista militiaman killed by contras, Mulukuku, 1985.

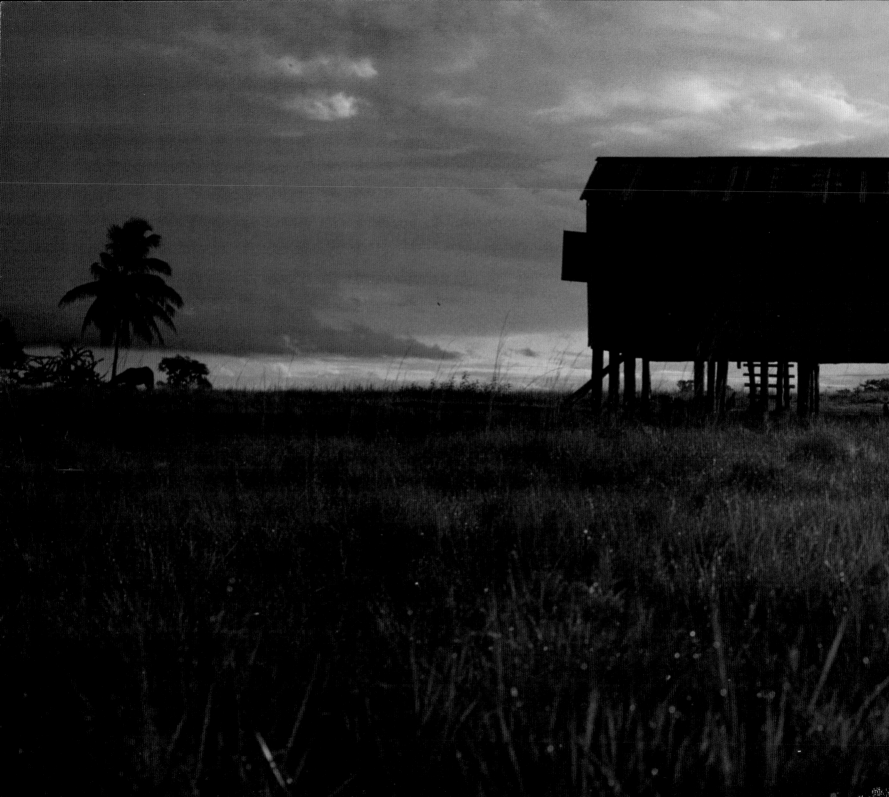

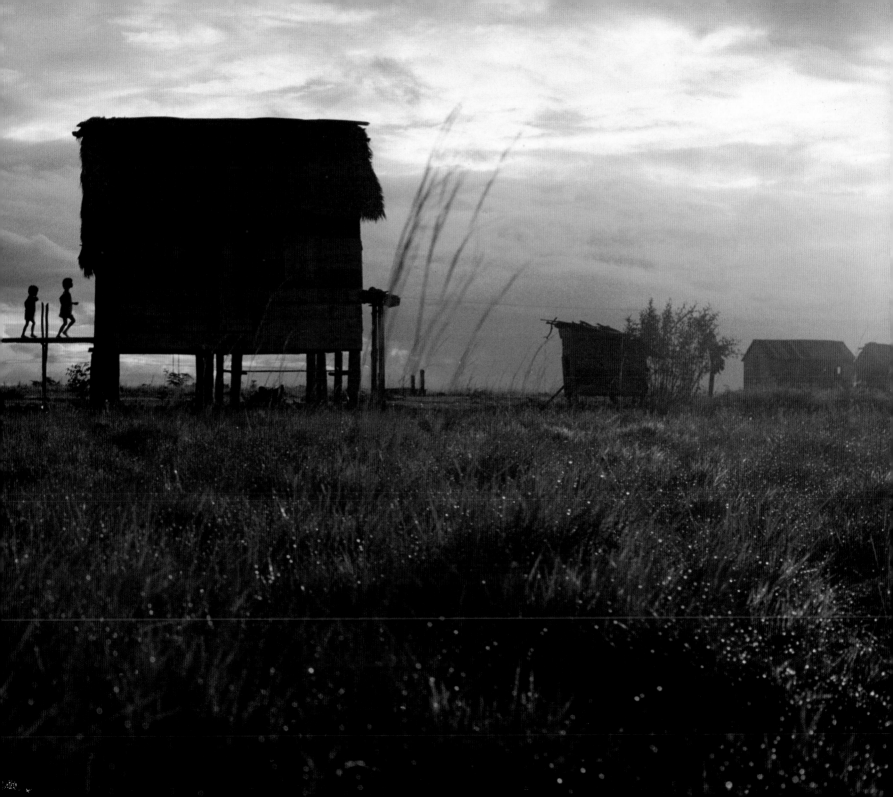

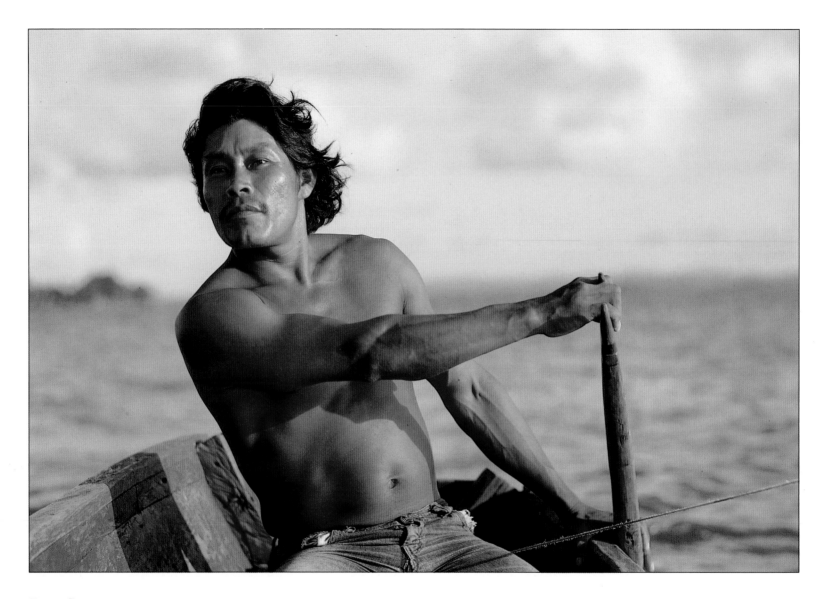

Rama Cay, 1988.

Overleaf: Yulu, 1986.

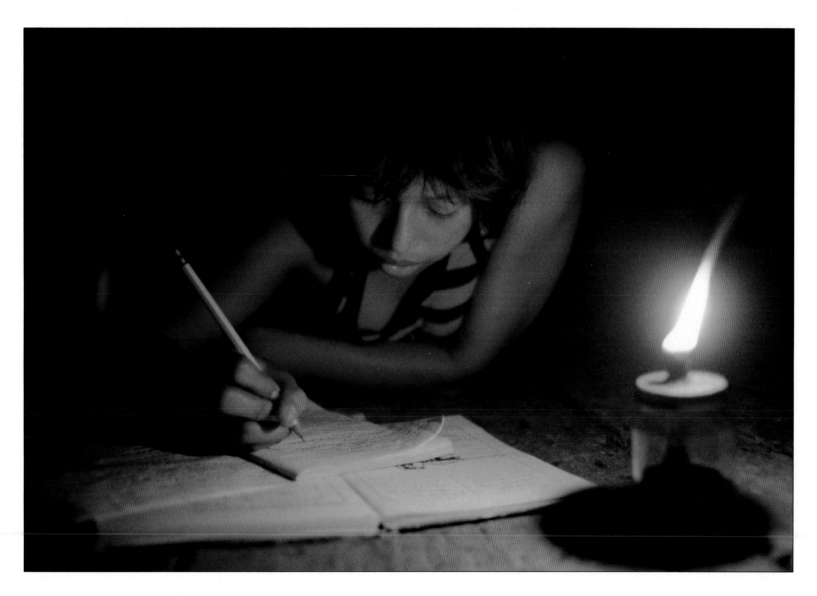

Rama Cay, 1988.

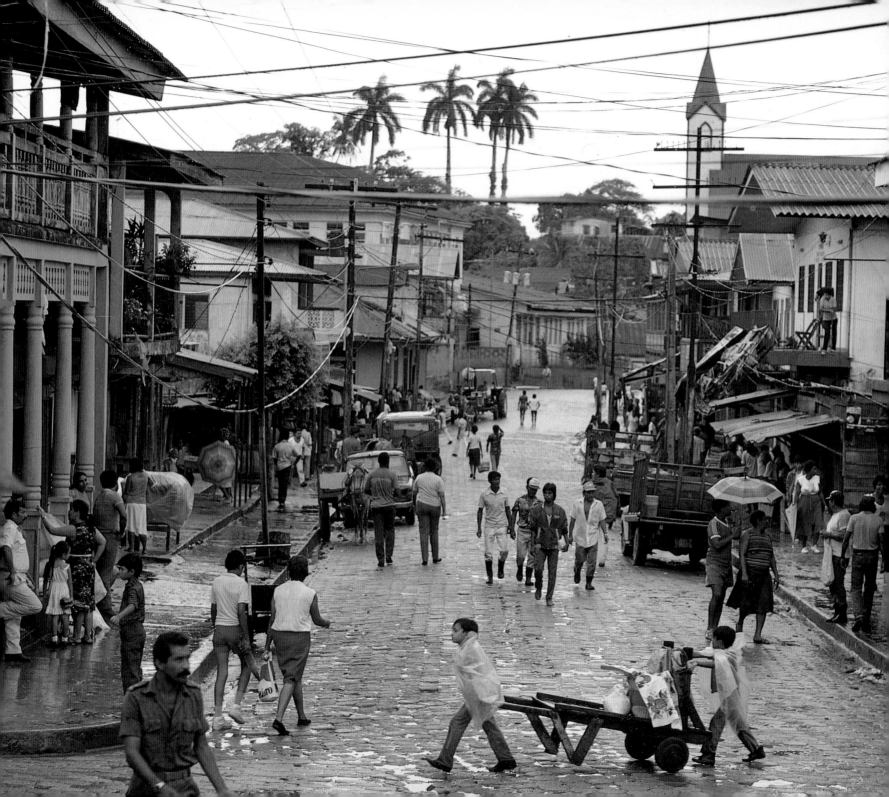

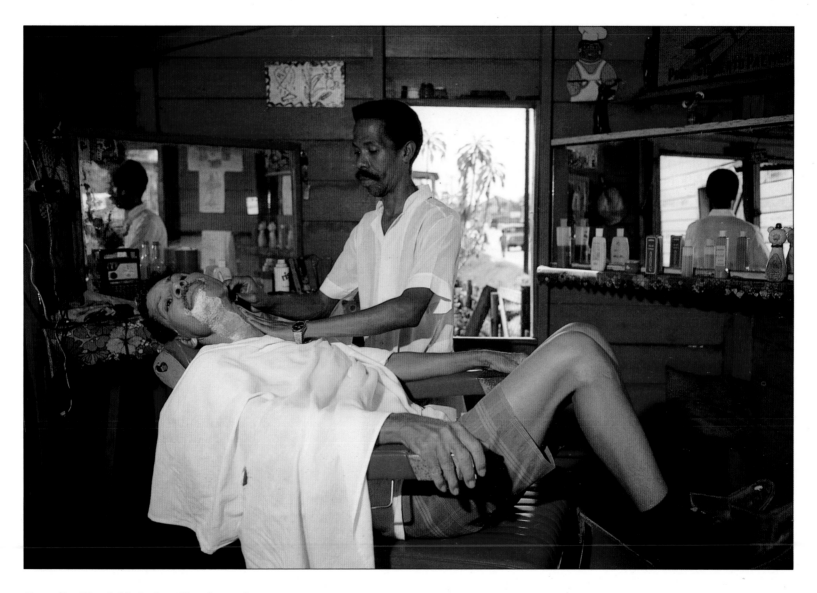

Opposite: Bluefields before Hurricane Joan, 1988.

Puerto Cabezas, 1986.

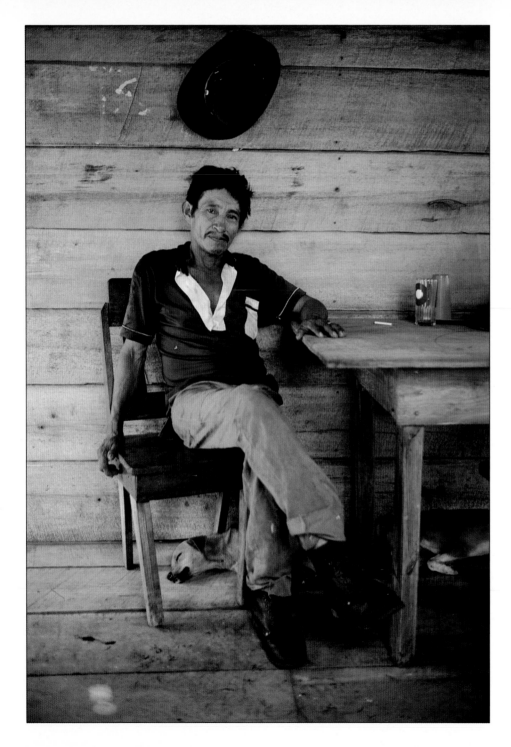

Miskito Indian, Yulu, 1986.

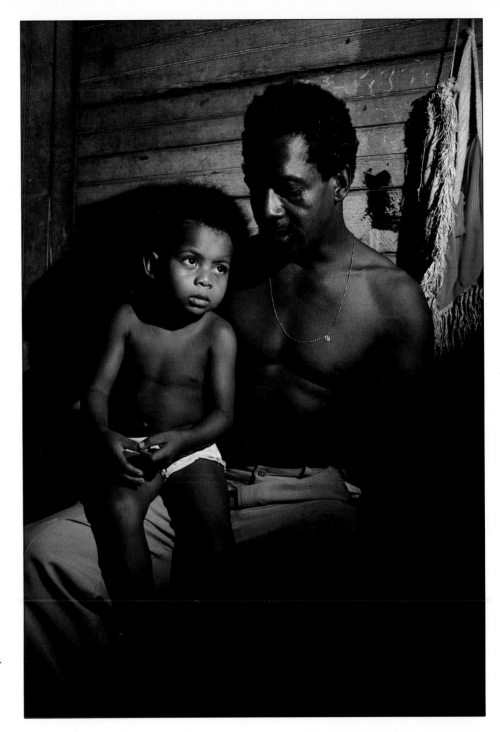

Puerto Cabezas, 1986.

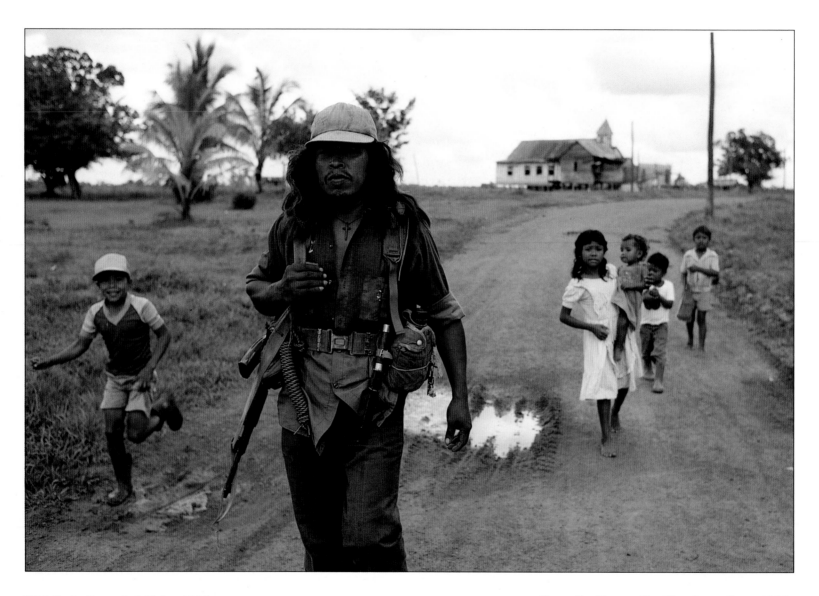

Miskito Indian rebel, Yulu, 1986.

Opposite: Rama after Hurricane Joan, 1988.

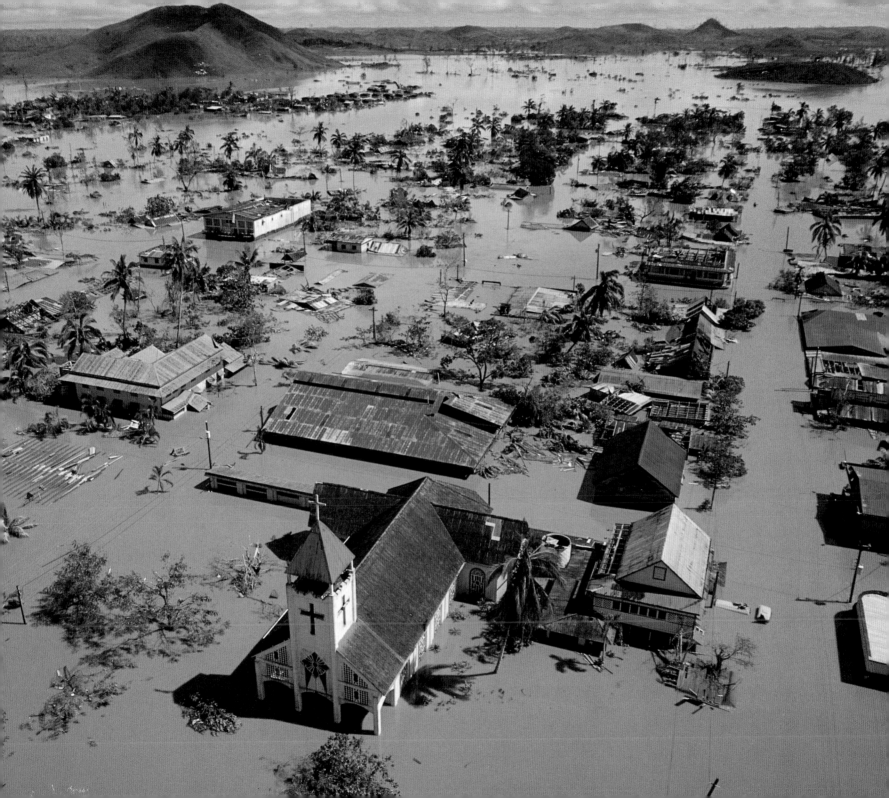

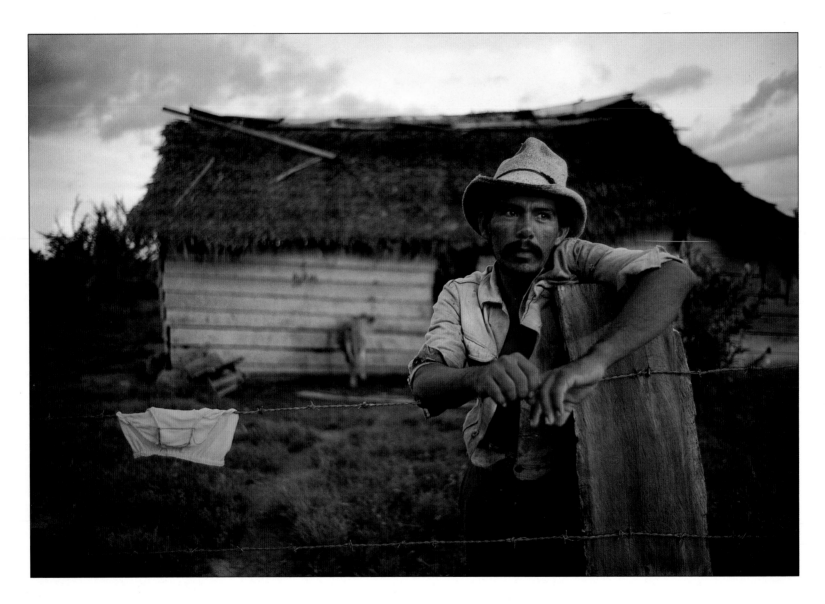

Matagalpa Department, 1986.

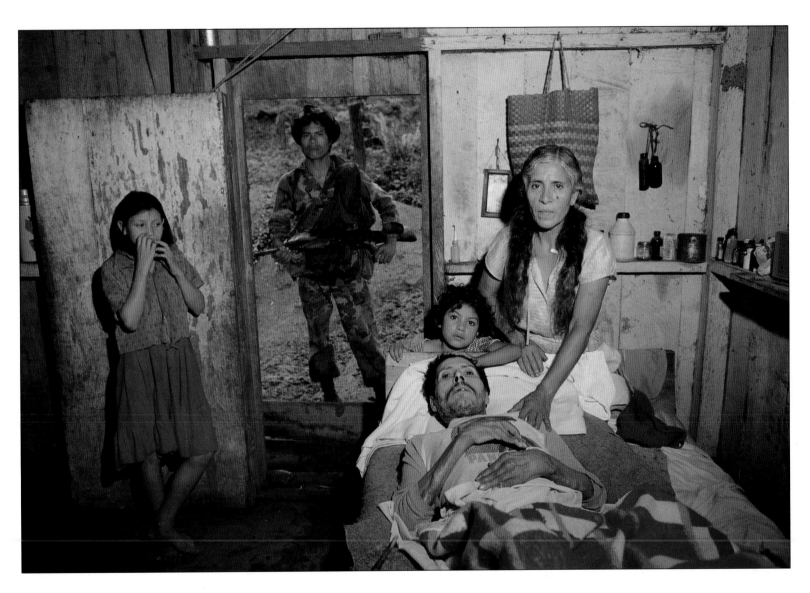

Dying man and family, Sandinista on patrol, Matagalpa Department, 1986.

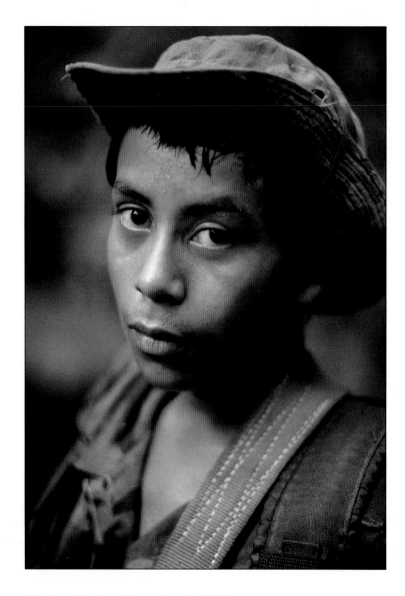

Contra, Jinotega Department, 1987.

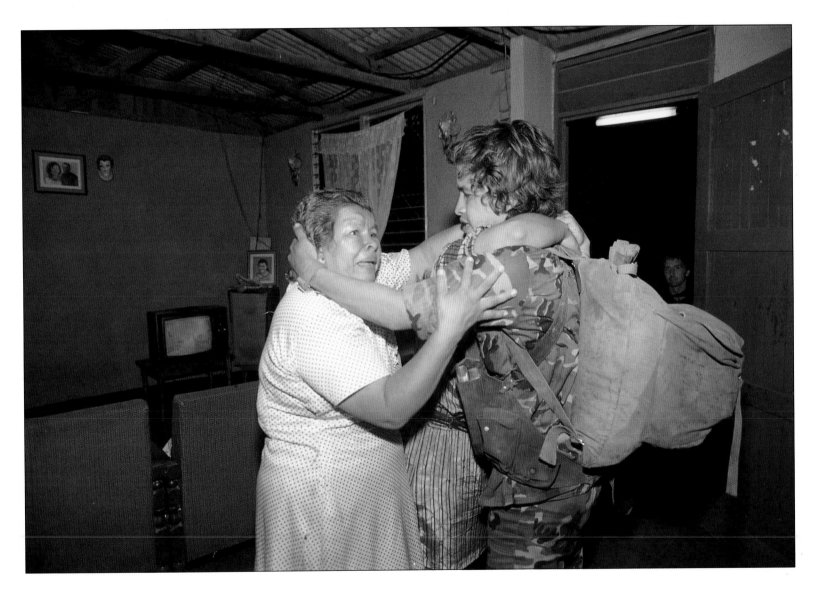

Sandinista soldier comes home, Managua, 1987.

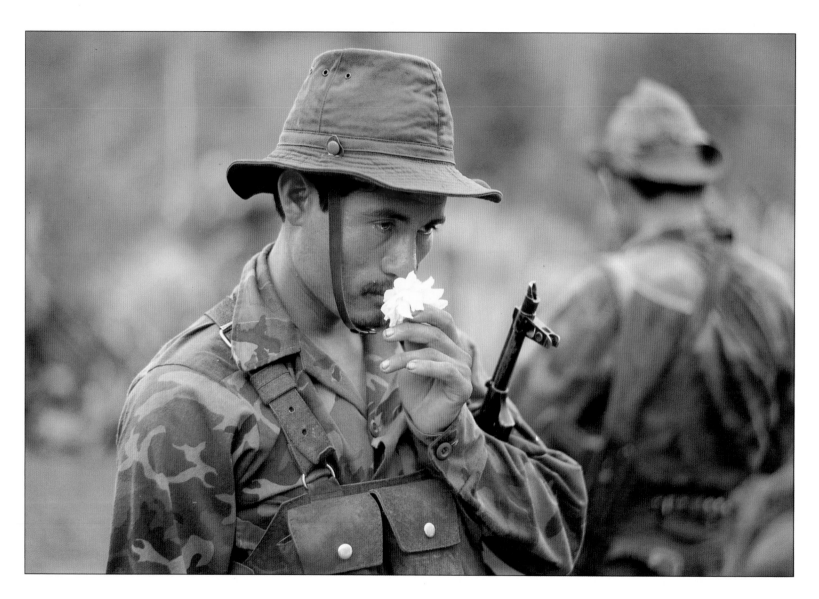

Sandinista, Matagalpa Department, 1984.

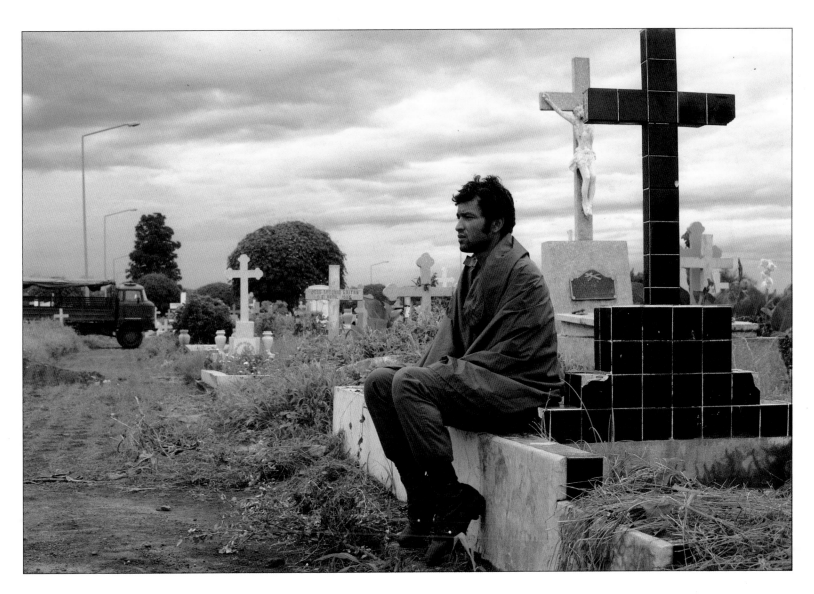

Sandinista at soldier's funeral, Managua, 1984.

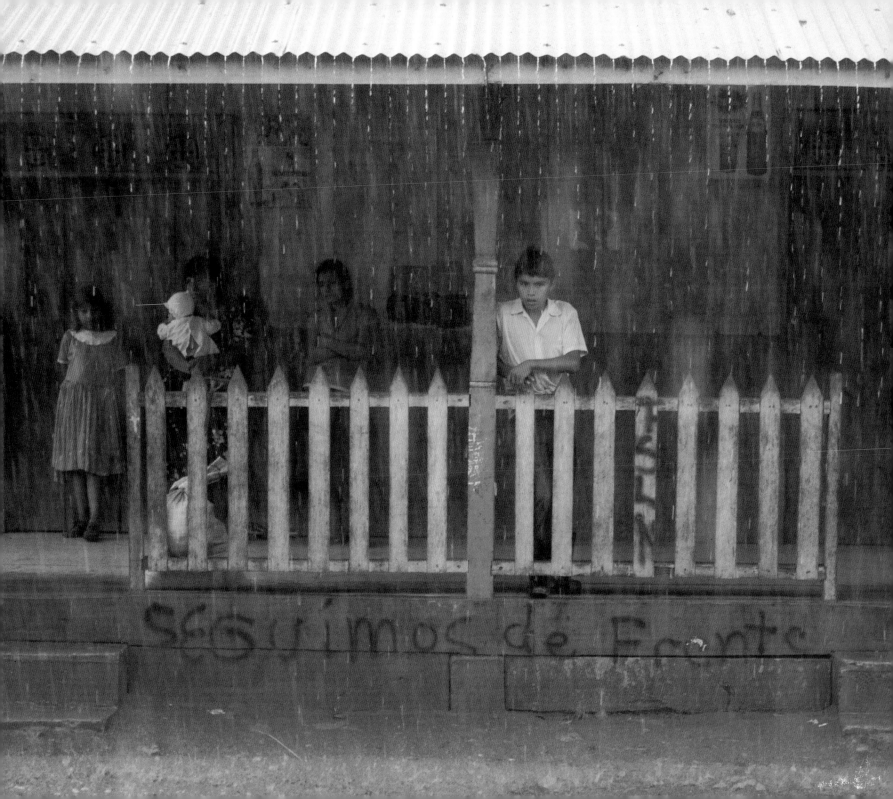

T o the great misfortune of Nicaraguans, their country became a symbol, and that symbol
became a battleground on which North Americans argued over what role the United
States should play in the world and in the hemisphere. The symbolic Nicaragua of
Washington's policy debates bore little resemblance to the real Nicaragua, but the policy war
in Washington nevertheless spawned a real war, dirty and bloody, devastating the lives of
ordinary Nicaraguans. The comment of Salvadoran Archbishop Rivera y Damas on the role
of the superpowers in his country's civil war applies equally to Nicaragua: "They supply the
weapons, and we supply the dead."

William M. LeoGrande
Washington, D.C., 1988

Nicaragua and the United States . . . are going towards either total confrontation or towards understanding. I believe the position of total confrontation is being defeated and the way to understanding is being cleared. But we have only these two roads. There are no others.

Sergio Ramírez Mercado
Managua, 1988

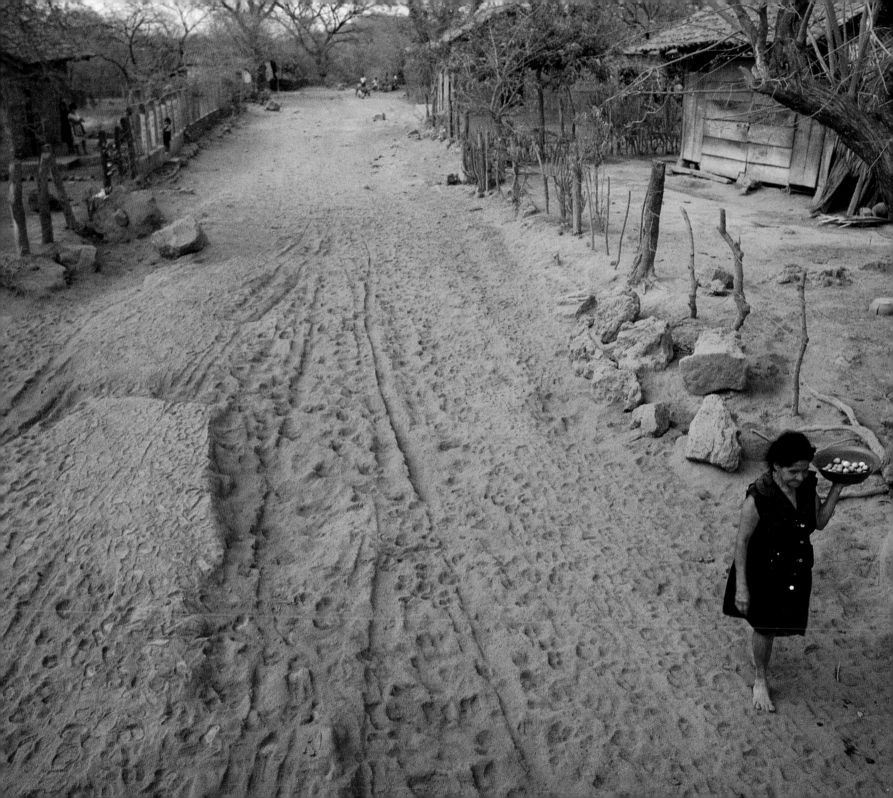

Interview

AN INTERVIEW WITH SERGIO RAMÍREZ MERCADO

WILLIAM FRANK GENTILE: Should we start with the Conquest of Nicaragua?

SERGIO RAMÍREZ MERCADO: I believe we should start a bit further back. They taught us in elementary school that during pre-Columbian times Nicaragua was a territory of confluence. People came here fleeing natural catastrophes and repression from other, more powerful tribes. So this is a country of asylum. Tribes poured in from the north, from Mexico. And from the south, from Paraguay and Peru. There was a fusion of pre-Hispanic indigenous cultures.

The Caribs who came from Paraguay settled on the Atlantic coast. The Toltecs and Niquiranos came from the north. When the Spaniards arrived, three basic communities existed in Nicaragua: The Niquiranos, who occupied land from the Gulf of Nicoya to the Isthmus of Rivas; the Chorotegas, who had settled all around the Masaya Lagoon; and the Niquihinomos, whose capitol was in Rivas. A branch of the Chorotegas migrated to the western plains. These two branches of the Chorotegas had their differences and went to war, so the historic conflict between east and west has existed in Nicaragua since pre-Columbian times.

Our society started evolving long before the Conquest, and continued through the meeting of different peoples, through the mingling of cultures.

How would you characterize the Conquest?

The repression was especially brutal because Nicaraguan slave labor was used by the Spaniards to carry out the Conquest of Peru. What interested the *Conquistadores* was the colonizing of Peru. Gold was the

main attraction. The Spaniards didn't want to extract wealth from Nicaragua; it was human labor they wanted. Indians were forced south to be slaves in Peru. The Conquest was particularly brutal here. In fact, it was a bloodbath.

And the *Conquistadores* were at each other's throats. The founder of the cities of León and Granada, Francisco Hernández de Córdoba, was decapitated by Pedrarias Dávila, who was the first Somoza of Nicaragua. Dávila amassed an incredible amount of wealth, lived to be over 90 years old, and passed his power on to his descendants. He was the symbol of the iron fist of the Conqueror.

It seems that the Nicaraguans do not carry the psychological or spiritual wounds that other conquered societies bear.

The Conquest was a long time ago. Nicaraguan society has developed over many centuries under the domination of the landholder whose power was based on lands assigned to him by the Spanish Crown. The surviving Indians seemed to be oppressed not so much by the Spaniards as by the dominant class which was created by colonization. The economic power of this class was based primarily on the ownership of vast estates and on cattle raising.

Is it true that coffee was not introduced into Nicaragua until the 19th century?

Yes, as in all of Central America, it was introduced in the second half of the 19th century. Land began to move out of the hands of the Catholic Church, the principal landholder after the Conquest; a new class came to power, thriving on modern agricultural methods.

And cotton?

The Indians cultivated cotton but it wasn't until after the Second World War that it was produced on a large scale for export.

So with coffee Nicaragua became an exporter of agricultural products?

No. First it was indigo, a vegetable dye. After that, the main export was tanned leather. Not meat. The technology for preserving meat did not exist. Meat was just a by-product of leather, for internal consumption. That is why our diet here is based on beef. Later, coffee "modernized" Nicaragua. It was exported to Europe and the United States, and manufactured goods came into the country in exchange.

What makes Nicaraguan history different from that of other Central American countries?

For one thing, at one time or another in its history, Nicaragua has been a center of world attention. Our geography has awakened the lust of more powerful nations. In the 19th century, even in colonial times,

Nicaragua was seen as a possible path between the seas. The Spaniards were looking for exactly that. When Gil Gonzalez arrived early in the 16th century, he was amazed to find a fresh water sea. This was Lake Nicaragua, which has an outlet to the Atlantic. Here was the route between the seas. Panama also offered possibilities, but these were less attractive.

The English landed in Nicaragua on the Atlantic side, and took possession of this passage. And it wasn't long before the United States was on the scene, with the same purpose in mind.

The first American to appear in Nicaragua was Cornelius Vanderbilt, who obtained a concession to establish the Accessory Transit Company, to provide cheap passage from the east coast of the United States to California. That was in the 1840s. Though Panama was narrower, it was much more difficult to cross because the land was swampy and bred disease. So Vanderbilt set up his company in Nicaragua. Ships brought passengers from New York to the port of San Juan del Norte. Other ships carried the passengers to the port of La Virgen on Lake Nicaragua. From there they went by stagecoach to San Juan del Sur, on the Pacific, and boarded ships that took them to California. This was the fastest and cheapest passage.

The Conquest of the West in the United States, the Conquest of California, was made in part through Nicaragua. Thus there is this historic and cultural connection between the two countries.

What influence has this world attention had upon the formation of the Nicaraguan character?

I can't speak of the Nicaraguan character without reference to certain facts of our history. Nicaragua's geographic position invited a good deal of profiteering. This gave rise to two distinct camps in Nicaragua—one in support of U.S. interests and one in opposition. The group that sided with the United States was in power at the time. The other group was a minority, led by an educated sector of society, nationalistic and anti-imperialistic in its views. These were the sentiments that Sandino appealed to in 1926. These tendencies have been present throughout the history of Nicaragua.

What do I mean by all this? That there are people who, to protect their economic interests, their social position, etc., do not want to defy the status quo. And this status quo implies ties to a foreign power. If you speak to intellectuals of the right here, you will find that they are terrified of breaking ties with the United States.

But why?

Because the theory of Manifest Destiny has been ingrained here. The idea persists that small countries cannot make a move without the protection of the Colossus of the North. It's an intellectual, a psychological, and a cultural attitude. They believe that it is madness for Nicaragua to risk confronting the United States. What insanity! How dare this little country expel

the United States Ambassador? This kind of attitude has led to extremely servile behavior toward the interventionist power.

But this is a geopolitical analysis. What about a description of the Nicaraguan character?

I speak in these terms because when idealist methods are used to interpret the characteristics of a people, one tends to exaggerate or distort. For example, when Octavio Paz talks about the Mexican in *The Labyrinth of Solitude*, or when Pablo Antonio Cuadra talks about the Nicaraguan in his book *The Nicaraguan*, you will find a number of attractive ideas, but I don't think they have much substance. Cuadra, for example, speaks of the Nicaraguan as having a *processional* character. He saw the Nicaraguan as always moving in a procession. Why does he say this? Because everywhere on the roads you see Nicaraguans moving from one place to another in large groups. He says the Nicaraguan has always been rootless, always ready to pull up stakes. He gives the example of their shacks, which are not sturdy but fragile, always ready to be taken down and carried to another place. But it seems to me that if somebody had the opportunity, the education and the means to build a house that was made not of straw but of bricks, that person would build a brick house and not be a perpetual migrant. I'm very wary of this sort of romantic interpretation.

Aren't there some definitions of this sort that might be less superficial?

Well, it seems to me that the Nicaraguan from the Pacific is talkative, gregarious, extroverted, and compassionate. You see this in daily life. My father was a man of the Pacific, from Masatepe, a *mestizo* city, with Spanish and Indian roots. When I was a little boy, if he was standing at the door of our house and somebody drove by looking for such and such a house, my father would give him directions, but this wasn't enough. He would call for me. "Wait," he would say, "take him with you." And I would get in the car and show them the way.

This is typical of people from the Pacific. They have a tremendous sense of neighborliness. On Saturdays they get together in backyards to have a drink. The Carazo Plateau where I was born—Jinotepe, Diriamba, Masatepe—is the center of a very important indigenous civilization. Rites and ceremonies are integral to daily life. Indigenous culture has blended with the Catholic; a novel fusion has taken place. The feast of the local patron saint is mainly a get-together where everybody eats. The role of the steward of the feast is to make sure everybody has some food. The people bring gifts to the steward— cows, pigs, chickens, corn—and he gives something to eat to whoever comes. The father of one of the heroes of the revolution lives in Masatepe. He is a very poor carpenter who always insists on being the steward of the feast of a black Christ who is venerated in that town. He loves giving food to everybody. His doors are wide open

day and night, and people arrive with empty plates and go away with full ones.

This is a part of our essence: solidarity, giving, unselfishness, at least among the poorest. When society stratifies there is more individualism and competitiveness, especially among the rich.

Here's another important element—who colonized Nicaragua? Mainly Spaniards from Extremadura and from Andalusia, with its Arabic heritage. An Andalusian is more open than a Galician or a Catalonian. He is more talkative, more of a reveller. Knife in hand, he goes looking for a fight. He's a womanizer, he is macho. These were the men who colonized Nicaragua, along with those from Extremadura, who were poverty-stricken. In Extremadura the land is dry dirt; farming is minimal; it doesn't rain.

Are these national characteristics?

Not really. I'm talking now about the Pacific, which is where the population was concentrated. Nicaraguan culture took shape on the Pacific. In the north we have a mountain culture: Nueva Segovia, Matagalpa, Jinotega. Going inland one finds a less gregarious *campesino*. At a cultural or a political event in the north you will find that the response of the *campesino* is more quiet. Communication is difficult. Here I am venturing a guess, but it seems to me that in the north this difficulty is born of isolation. Outside of the little towns, every four or five miles, there are scattered little shacks housing five or six

people. There is no tradition of working or living in a community. People work alone on their little plot of ground. Conversely, the indigenous culture of the Pacific was communitarian. People worked the land together. Even the Spanish Crown had to recognize these communal lands.

The Atlantic is totally different. It is Caribbean, African.

But above all British. The colonization of the Atlantic coast was done from Jamaica. On the Atlantic the racial mixture is Miskito Indian-Black, or Miskito-British-Dutch. There are many cultures. The North Atlantic and the South Atlantic coasts are very different.

Many people have no idea that such a dramatic diversity exists in Nicaragua.

A tremendous diversity. And the influence of religion has been crucial. On the Atlantic the impact of the Moravian Church, a Protestant church, has been very important. One of the things that we learned after the Triumph in 1979 is that on the Atlantic coast you must not shout during speeches. There you talk like the minister. On the Pacific the speeches are high-pitched; they are meant to arouse. On the Atlantic this shouting would annoy people.

A fundamental factor in all of this is the traditional lack of communication between the Pacific and the Atlantic. This has created a division so great that on the

Atlantic they still refer to people from the Pacific as "the Spaniards." Integrating these two regions of the country is a complicated historical task.

The most important cultural influence in Nicaragua has been the Catholic religion, which the people practice with a pagan religiosity. The religion that existed here before the Conquest used symbols and religious imagery. Idols were venerated and called upon to send rain. Sacrifices were offered to ensure abundant corn. This was the basis of the indigenous culture. What people needed for their survival—for harvest, for rain, for war—was connected with a sacred power.

And how is that expressed today?

With processions and cult celebrations, which have a mixture of Spanish and indigenous elements. This religiosity is expressed in many ways, depending on the patron saint of each locality. Each community has its own saint protector.

The stereotype of Nicaragua is that it is a land of lakes and volcanoes. What else defines Nicaragua?

Racial blend. Our *mestizaje* is of major importance. Only those from the Atlantic coast—the Miskito, the Rama, the Sumo—are pure Indian. The majority of us Nicaraguans have a mixture of Indian and Spanish blood.

I am looking for a symbol that could explain the Nicaraguan

spirit. It seems to me that the Macho Raton character in the Guegüense drama represents, in a way, the Nicaraguan attitude toward life.*

Yes, The Macho Raton helps explain an aspect of the Nicaraguan character, the Nicaraguan sense of humor. The Nicaraguan puts on an armor of humor when facing difficult situations. Life here is incomprehensible without humor, without irony. True humor allows you to laugh at yourself. If you can't laugh at yourself, you really have no humor at all. I think we have that ability to make light of the most difficult, the most uncomfortable situations. Humor is really an attitude of self-criticism, an attitude that provides distance and allows us to laugh at ourselves and at each other.

I think the Macho Raton illustrates three things: the pride of the subjugated before the oppressor; humor as a means of defense, a kind of shrewdness; and a tremendous ability to improvise when confronted with difficult situations. These three things have emerged in the historical situation of our being unequal to the superior forces we were up against, powerful forces that were capable of wiping us out completely. Intelligence and shrewdness have developed in this battle of the strong against the weak. Without that sense of national pride we would not be able to defend ourselves. The synthesis of

*The Macho Raton and the Guegüense are the main characters in a traditional Nicaraguan comedic folkloric dance in which local Indians ridicule their Spanish conquerors.

these three elements constitutes for me our national dignity.

To change the subject, why are so many Nicaraguans poets?

Poetry has been in the culture since Rubén Darío's time. It's an expression of the educated, but it also has a popular dimension. Poetry in Nicaragua was a rare occurrence before Darío. After Darío it was a steady stream, generation after generation of Nicaraguan poetry. It's as if Darío had touched a magic chord and given form to this poetic sensibility. Poetry enhances the Nicaraguan's sense of self-esteem. It helps to draw the special profile of the Nicaraguan, that pride in being born in a land of poets and warriors. Rubén Darío was buried with honors never before seen. His funeral was attended by people from all social classes—artisans, farmers, city workers, people of the streets, even the aristocracy. He was buried in 1916 as a hero. Darío created an admiration for poetry, for the music of poetry, among the common people, even people who could not read.

And pride in being a poet.

Of course. From there one moves to creativity. Here you find poets in the barber shops, in the tailor shops.

In the mountains with the soldiers.

Everywhere. Since Darío's time this phenomenon has been steadily growing. It is strange that this love of poetry flourished in a country with so much illiteracy. This is important to mention, because we (the Sandinista government) inherited a country that was almost 70% illiterate. The general culture level was very low.

So Darío was a hero of the taverns, a popular hero. Even if nobody could read him, they knew his poems by heart.

If Darío opens a secret door and stimulates this sensitivity to poetry as one element of the Nicaraguan character, what is the door that Sandino opens?

If Darío represents our poetic identity, Sandino symbolizes our warrior identity, this being a country of poets and of fighters. These are really the two poles of our national identity. These are two very important elements in the definition of our national spirit, in the pride of being Nicaraguan.

What is Sandinismo?

Sandinismo is the expression of our deepest identity. It is the defense of the nation, of its political, social and cultural values. This is essential if our country is to survive. The Sandinistas do not believe Nicaragua can survive under foreign domination. This is basic. I am therefore a Sandinista before anything else.

Were you a Sandinista before the Sandinista movement?

Yes, a Sandinista since I opened my eyes to politics, to reality, at the university—when I was 17 years old.

But what is Sandinismo in practice?

It's a way of acting, a political and cultural behavior. But more than anything it is a conviction, an idea, an attitude to life. We have taken responsibility for the fact that we were born here, that we live here, that we must defend what we have, the unity and independence of our territory. We assert the fact that we must have respect from abroad. To the extent that we are respected we will be strong.

This is beyond any ideological tendency. It is what mobilizes people, whether they have Marxist ideas or not. It is a powerful force for unity. Respect for the country, for its integrity and independence.

This is the typical dilemma of a small country. Because it is small, it particularly needs to be respected—not subjugated. In a rich and powerful country it is perhaps more difficult to establish this idea of respect as a symbol. The United States has its power, its riches, the people's pride in being American. . . . On the other hand, we are proud precisely because we are poor.

The people of Nicaragua have endured an enormous amount of punishment; the 1972 earthquake, the war against Somoza, the contra war, and the economic crisis. Your traits as a people—humor, courage, generosity, spontaneity— aren't these in danger of being eroded because of this prolonged crisis? How much longer can people endure?

Granted that the situation is difficult, we must not forget that this is a country that has been formed by adversity. This is not the first difficult time . . . I don't think the present hardships will stifle a character that has been forged throughout our entire history, especially when new factors are at work. Our revolution is a tremendously important factor. Though the revolution hasn't been able to satisfy all the economic and social necessities of the poorest in Nicaragua, it has neverthe- less produced very profound changes, changes that could not have occurred during Somoza's regime. Under Somoza there were times which were actually much harder, without hope in sight.

What kind of relationship should the United States seek with Nicaragua?

What is at stake—and this is truly a fundamental point—is whether or not the United States can tolerate a small country becoming independent, a country that traditionally has been submissive to the United States. The issue transcends the case of Nicaragua—we are a small country, with little or no influence in the game of world politics, and with no strategic wealth; even our geographic position is no longer of strategic value.

But we are important because of what is happening

here. Nicaragua is forcing the United States to have a different kind of relationship with Latin America. If what is happening here succeeds, no country in Latin America will put up with being dominated by the U.S.

Does the United States resist this new relationship with small countries? What is there to lose?

I don't think anything would be lost. I think that if the United States had decided to have a good relationship with Nicaragua it would have gained more than what it has gained by infringing upon us.

Is Nicaragua independent from the United States?

For me it is obvious that not only are we independent of the U.S., we are confronting the U.S., which demonstrates our independence.

But the United States still partially determines if there is hunger or not in Nicaragua, if there is war or not in Nicaragua.

That is another problem. But we have already taken the first step, and we're going towards either total confrontation or towards understanding. I believe the position of total confrontation is being defeated and the way to understanding is being cleared. But we have only these two roads. There are no others.

Sergio Ramírez Mercado is the current vice president of Nicaragua. When the Sandinista National Liberation Front (FSLN) gained power on July 19, 1979, he became a member of the original five-person Junta of National Reconstruction. Prior to the Sandinista victory, Ramírez belonged to the "Group of Twelve," a diversified coalition of Nicaraguan leaders opposed to the Somoza dictatorship. Born in the town of Masatepe in 1942, Ramírez is an internationally renowned author. He is considered among the most knowledgeable sources of information on Nicaraguan history, a leading analyst of current events in his country, and an astute observer of his people.

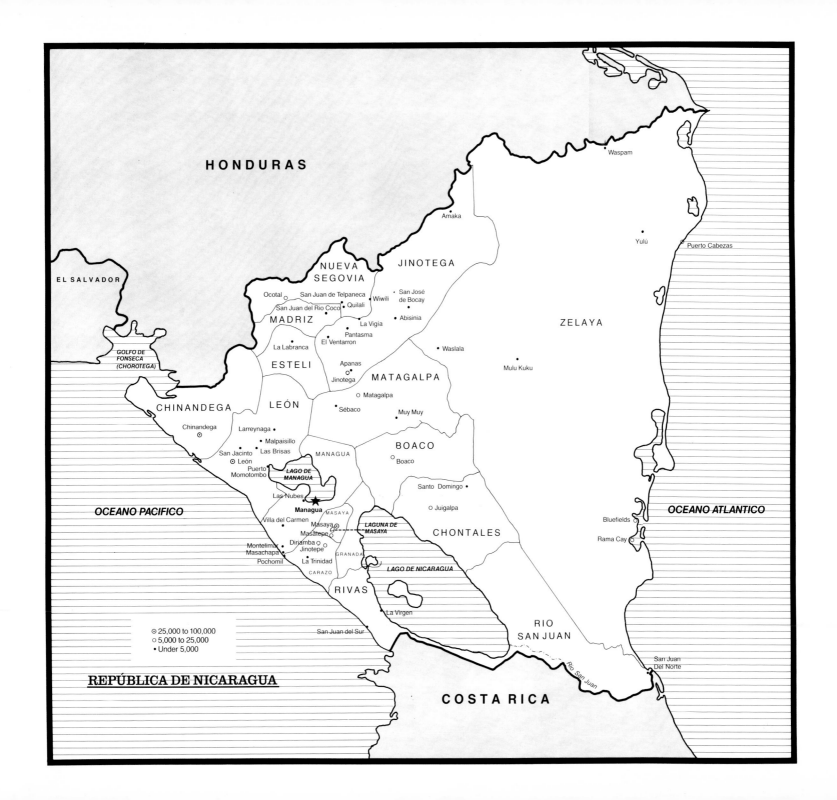

HONDURAS

EL SALVADOR

GOLFO DE
FONSECA
(CHOROTEGA)

OCEANO PACIFICO

CHINANDEGA

Chinandega

Larreynaga

Malpaisillo
Las Brisas

San Jacinto
León
Puerto
Momotombo

LEÓN

MANAGUA

LAGO DE
MANAGUA

Las Nubes
Managua
Villa del Carmen
Masaya
Masatepe
Montelimar
Masachapa
Diriamba
Jinotepe
Pochomil
La Trinidad

MASAYA

GRANADA

CARAZO

RIVAS

La Virgen

San Juan del Sur

⊙ 25,000 to 100,000
○ 5,000 to 25,000
• Under 5,000

REPÚBLICA DE NICARAGUA

NUEVA
SEGOVIA

Ocotal
San Juan de Telpaneca
San Juan del Rio Coco
Quilali
MADRIZ
La Vigia
La Labranca
Pantasma
El Ventarron
ESTELI
Apanas
Jinotega
Sébaco

Matagalpa
Muy Muy

BOACO
Boaco

JINOTEGA

Amaka

Wiwili
San José
de Bocay
Abisinia

Waslala

MATAGALPA

Santo Domingo

Juigalpa

CHONTALES

LAGUNA DE
MASAYA

LAGO DE NICARAGUA

RIO
SAN JUAN

Rio San Juan

ZELAYA

Waspam

Yulú
Puerto Cabezas

Mulu Kuku

OCEANO ATLANTICO

Bluefields

Rama Cay

San Juan
Del Norte

COSTA RICA

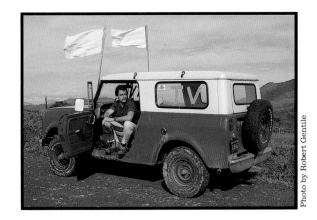

WILLIAM FRANK GENTILE

At the height of the Sandinista-Contra War in the mid 1980's, Nicaragua's foreign press corps regarded Bill Gentile as the most daring—and perhaps the most reckless—of the guild. It was as though he found something so disturbing in the photographs he was making that, in order to understand what he was seeing, he was compelled to expose himself to the same dangers Nicaraguans lived with every day.

A more deliberate, highly sensitive photographer eventually emerged from that dark period, a man still drawn to the battlefield but who also became more aware of a Nicaragua larger than the war itself—a Nicaragua peopled not only with faces of despair and shattered dreams, but also with portraits of joy and enduring hope. For besides offering a shocking testimony of the brutal war visited upon an impoverished nation, this book is a thorough visual portrayal of a spiritually rich land, seen through the eyes of a man who has lived amongst its people and come to love them dearly.

Scott Wallace
Managua, Nicaragua
September 1988